C000218823

IMAGES OF LONDON

WANSTEAD AND WOODFORD

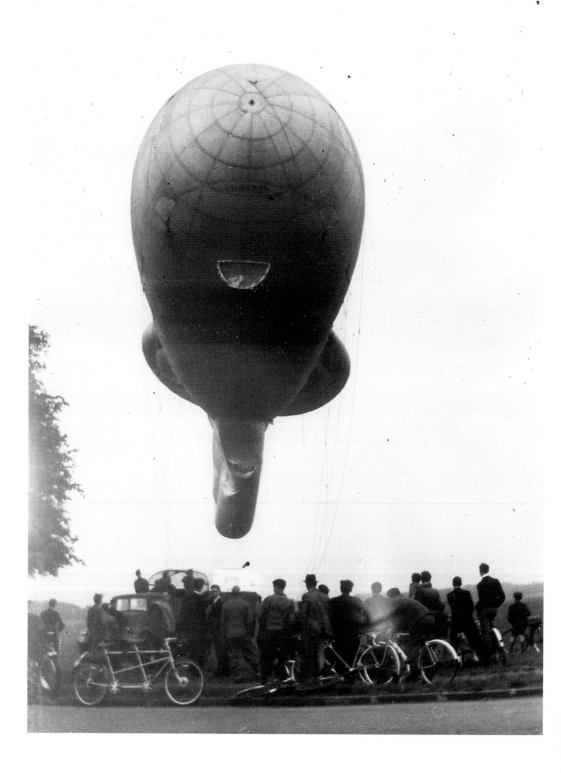

IMAGES OF LONDON

WANSTEAD
AND WOODFORD

IAN DOWLING AND NICK HARRIS

TEMPUS

Frontispiece: A barrage balloon tethered over Wanstead Flats, *c*.1942.

First published 1994
New edition 2003

Tempus Publishing Limited
The Mill, Brimscombe Port,
Stroud, Gloucestershire, GL5 2QG

© Ian Dowling and Nick Harris, 1994

The right of Ian Dowling and Nick Harris to be identified as the Author of
this work has been asserted in accordance with the Copyrights, Designs and
Patents Act 1988.

All rights reserved. No part of this book may be reprinted or reproduced or
utilised in any form or by any electronic, mechanical or other means, now
known or hereafter invented, including photocopying and recording, or in
any information storage or retrieval system, without the permission in writing
from the Publishers.

British Library Cataloguing in Publication Data.
A catalogue record for this book is available from the British Library.

ISBN 0 7524 0113 0

Typesetting and origination by Tempus Publishing Limited
Printed in Great Britain by Midway Colour Print, Wiltshire

Contents

Acknowledgements

We would like to thank Passmore Edwards Museum, Mr H. Harvey,
Mr L. Miller, Mrs J. Boyle, Mr G. Sharp, Woodford Photographic Society, Helen
Dowling, and also Sandra Haynes, Kathryn Eaton and
Stephen Kaniklides, the staff of the local history library.

Introduction

The joint urban districts of Wanstead and Woodford became a borough in 1937, which in 1965 merged with Ilford and parts of Chigwell and Dagenham to form the London Borough of Redbridge.

Both Wanstead and Woodford have histories dating back to Saxon times. 'Waenstade', meaning the site of a farm building, and 'Wudeford', meaning a ford by a wood, are both mentioned in the eleventh-century *Domesday Book*.

During the Middle Ages, both parishes were still heavily wooded as they came within the great forest of Essex. Wanstead was a collection of sparsely populated farms on the edge of woodland. Woodford was similar but had less farmland due to forest cover. By 1670 there were still only forty houses in the whole of Wanstead parish. Woodford had attracted many wealthy residents by the fifteenth century and this trend has continued up to the present day. By 1801, the Woodford population was 1,745, a high figure for rural Essex; it must have included many domestic servants working in the large houses. During the eighteenth century the forest in both parishes was greatly diminished by enclosures. The improvement of the road network from London by the Middlesex and Essex Turnpike Trust encouraged wealthy London merchants to come into Wanstead and Woodford.

The growth of stagecoach travel from 1790 to 1830 and the mid-nineteenth-century railway boom increased the prosperity of both parishes. Situated on the main routes north-east from London, coaching inns and, later, hotels and villas, proliferated. The Eagle Hotel at Snaresbrook was a local centre of many attractions including an angling lake, country villas, and the forest. An 1831 visitors' guide to Essex highly recommended Snaresbrook.

The 'great house' at Wanstead had been important since the fifteenth century under many royal or titled owners, including Robert Dudley, Earl of Leicester, in the 1570s. The house was rebuilt by Richard Child in Palladian style in the 1720s and it dominated the whole parish until its demolition in 1823. The influence of the grand

mansion encouraged wealthy residents to come to Wanstead. The remains of a group of early- eighteenth-century mansions around the George public house in Wanstead High Street testifies to the attractions of the village of Wanstead.

Woodford also had its large estates. Woodford Hall Manor included most of the parish. The owner before 1541 had been Waltham Abbey; it then passed through many owners until it was bought in 1710 by Richard Child of Wanstead. In 1869 the estate was sold for housing development. The smaller Monkhams estate and farms dated from the twelfth century. The manor house was rebuilt on various occasions. The early-nineteenth-century house was not demolished until 1930 although by this date most of its grounds and farmland had been developed for housing. The Ray House estate at Woodford Bridge and the Aldersbrook estate at Wanstead and Little Ilford also dated from the fifteenth and sixteenth centuries. These estates survived until the late nineteenth century when the spread of London into Essex increased the demand for housing land.

The amalgamation of the urban districts of Wanstead and Woodford in 1934 came at a time of rapid house-building throughout Greater London. This development, which included the new urban district, had started in the 1920s, and continued periodically until 1939. Both districts had retained areas of woodland or open spaces. Woodford still had three working farms in 1922. This mix of urban and rural still attracts residents to the area today.

<div align="right">

Ian Dowling and Nick Harris
November 1994

</div>

one
Wanstead

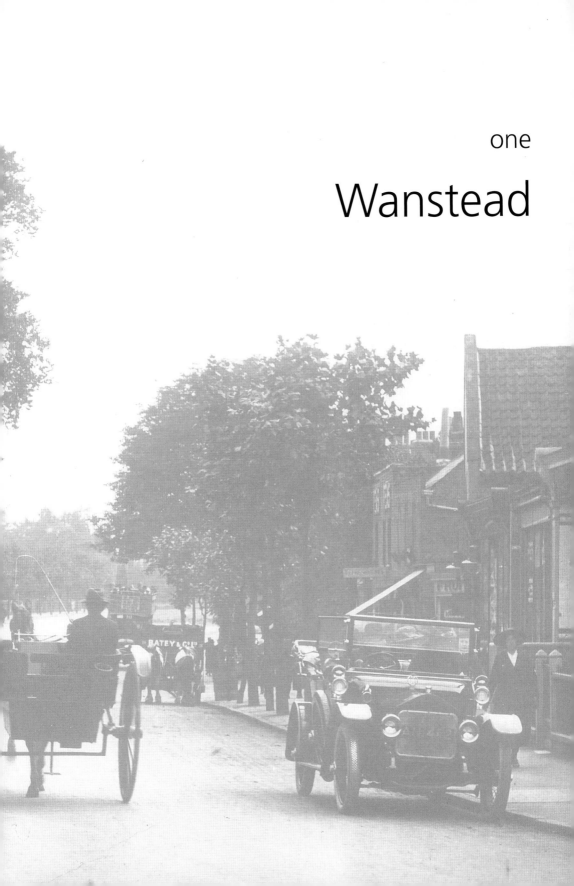

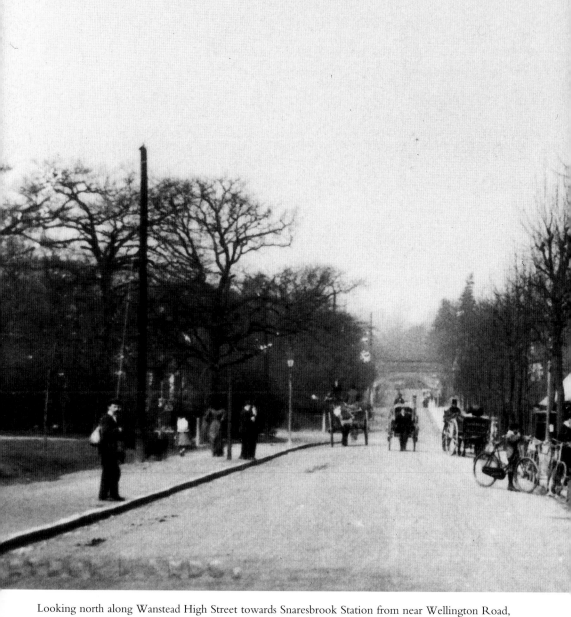

Looking north along Wanstead High Street towards Snaresbrook Station from near Wellington Road, *c.*1896. The station bridge can be seen in the background and an electric telegraph pole is visible on the left.

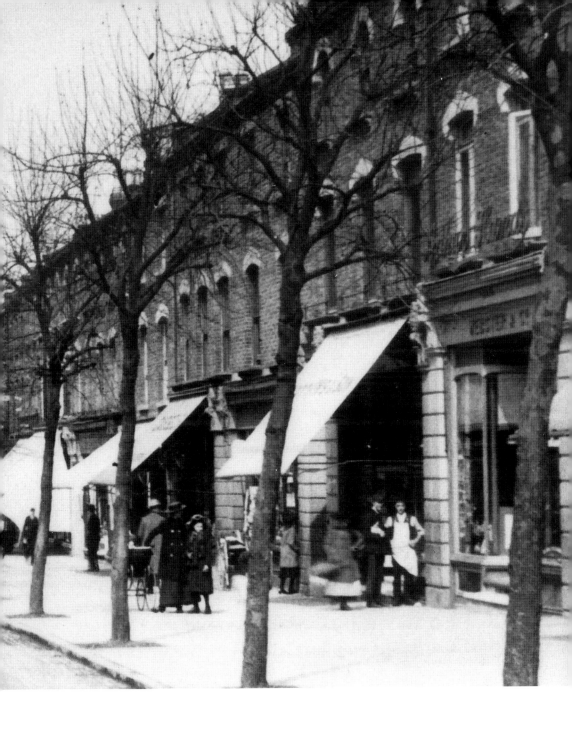

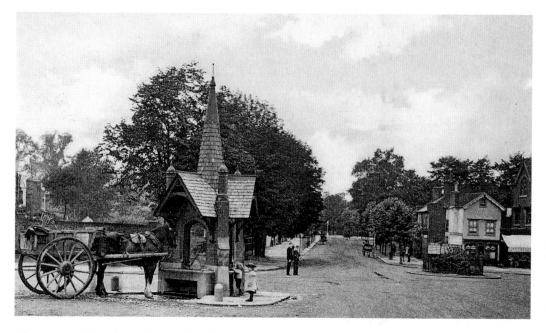

The junction of Cambridge Park and the High Street, *c.*1905. The drinking-fountain was erected in 1897 to commemorate the Diamond Jubilee of Queen Victoria's reign. It has been moved several times as the road has been widened.

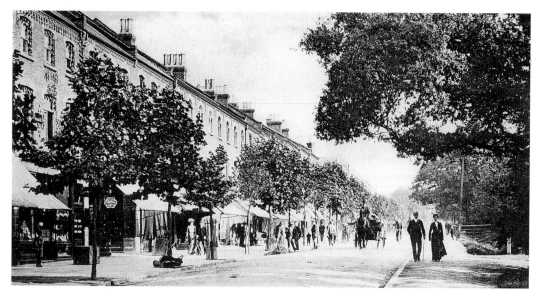

Wanstead High Street, *c.*1900. This southerly view from near Hermon Hill shows Mornington Terrace. The parade of shops included, at number 10, the offices of the *Wanstead Mail* and *Leytonstone Times* which was published every Friday.

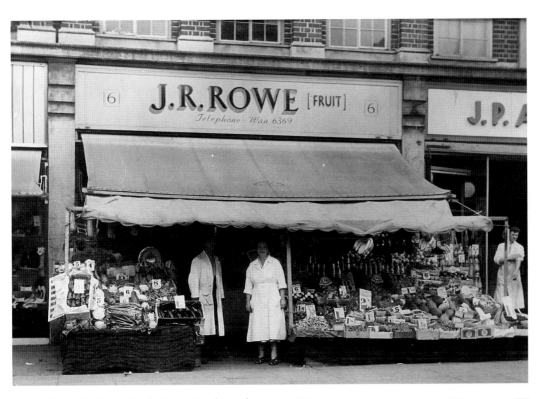

Above: Number 6 Clock House Parade on the High Street, *c.*1958. This was formally occupied by the mid-eighteenth-century Clock House.

Right: A street photographer's portrait of Mrs H. Miller taken while she was out shopping in the High Street, by Woodbine Place, in 1929.

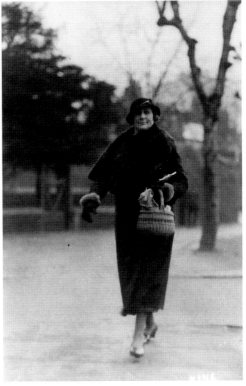

The High Street looking south to the junction with George Lane (now Eastern Avenue), *c.*1914.

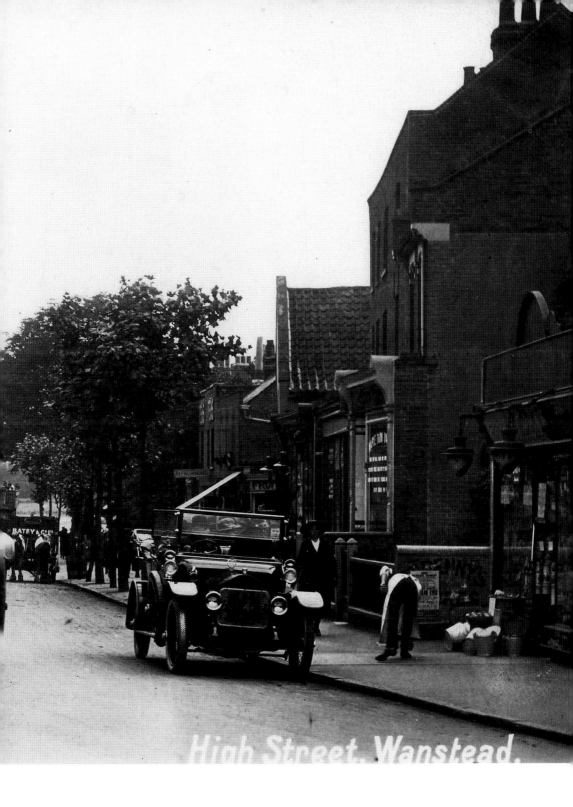

High Street. Wanstead.

15

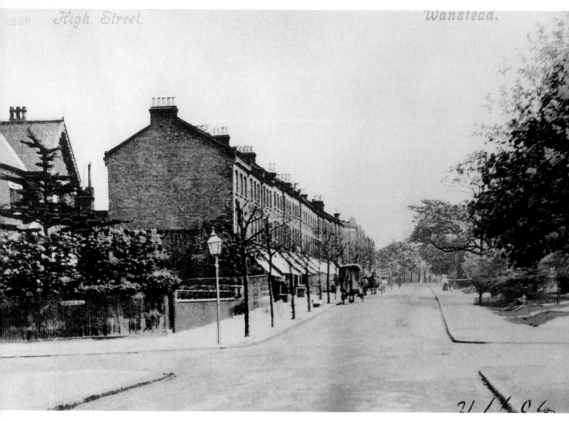

Wanstead High Street, c.1904. On the left of this view of Mornington Terrace is Hermon Lodge which was the office of Frank Argles, Medical Officer of Health to Wanstead Urban District Council.

Opposite above: The High Street and Cambridge Park junction near the George Hotel looking north, c.1900.

Opposite below: Looking towards Snaresbrook Station, from Hollybush Hill, near the junction of Woodford Road and Wanstead High Street, c.1900. The gardens to the right belonged to Mornington Lodge. The drinking-fountain was erected in 1872.

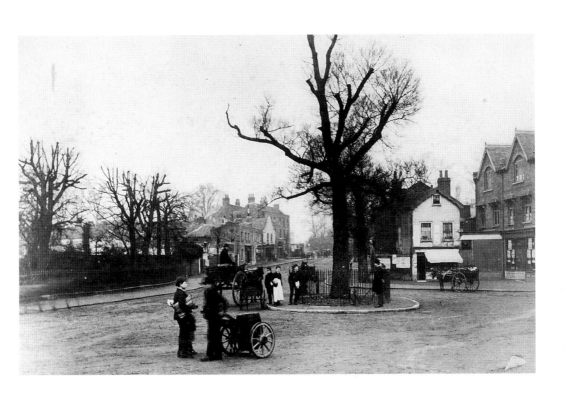

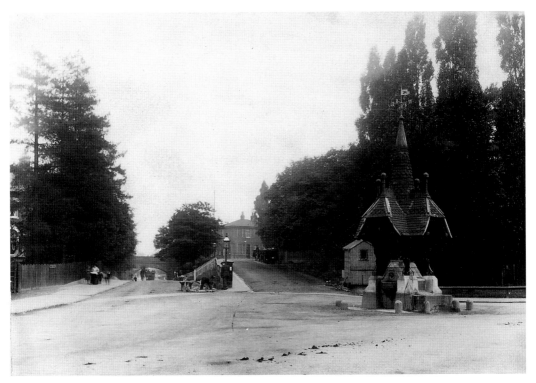

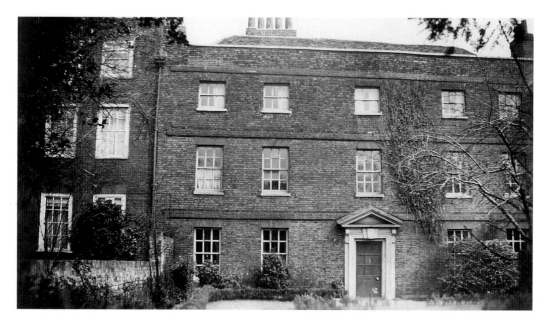

Stone Hall on the High Street, 1928/9. This three-storey, early-eighteenth-century brick house was one of a group of similar houses which have since been demolished or only survive behind shop fronts. Only the Manor House remains intact and is now used as the Conservative Club.

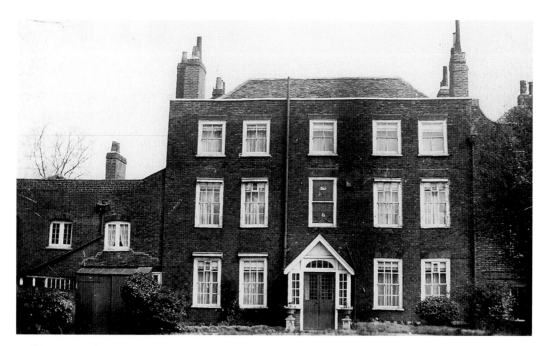

Mall House, High Street, 1928/9. This house to the north of Stone Hall was one of five Queen Anne mansions situated by the George public house.

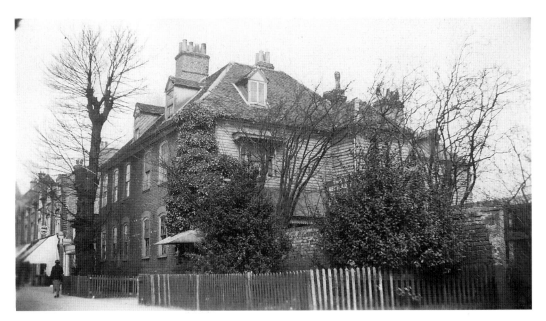

Wanstead High Street, *c.*1949. These eighteenth-century brick and timber houses between Grove Park and Grove Road were probably demolished when Clock House Parade was built in the 1950s. The British Restaurant shown on page 116, was built in 1943 on the site of the garden shown above.

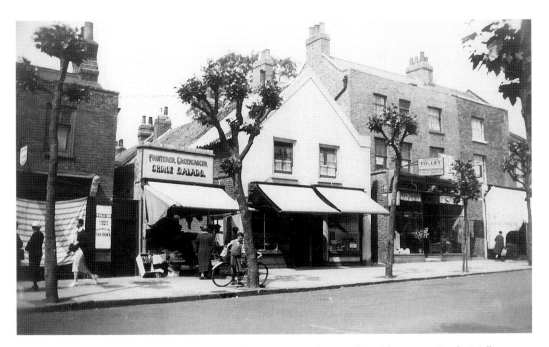

Numbers 36–46 on the High Street, near the junction with Woodbine Place, opposite the Mall Mansions, *c.*1949.

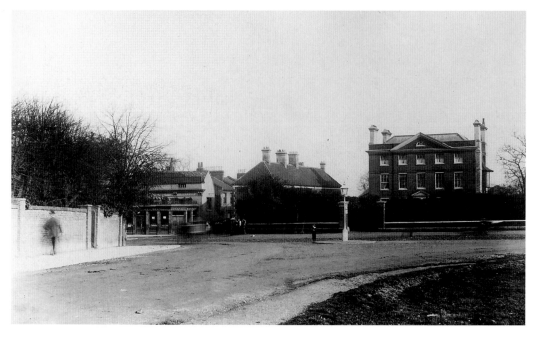

Looking towards the High Street and George Lane from Cambridge Park, *c*.1896. Sir William Penn's house, 'The Elms', is on the right.

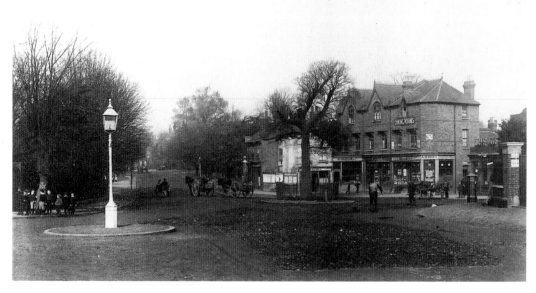

The south end of the High Street in October 1896. The George and Dragon public house is on the right.

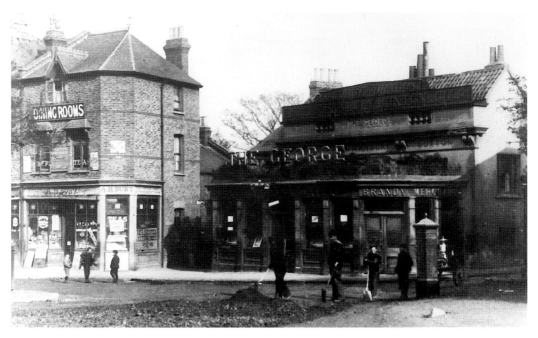

The George and Dragon, known as the 'George', in the High Street, 1900. This eighteenth-century building lasted four more years before being rebuilt.

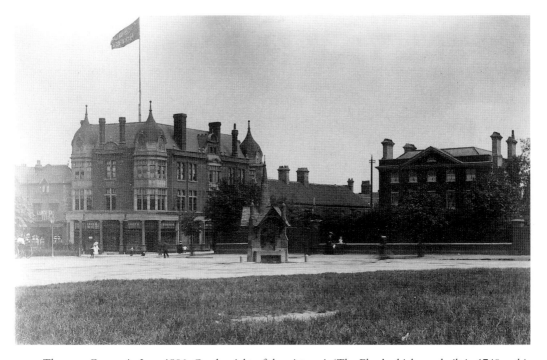

The new George in June 1906. On the right of the picture is 'The Elms' which was built in 1740 and is now the site of Wanstead Station on the Central Line. The drinking-fountain has been moved from its position shown on page 17.

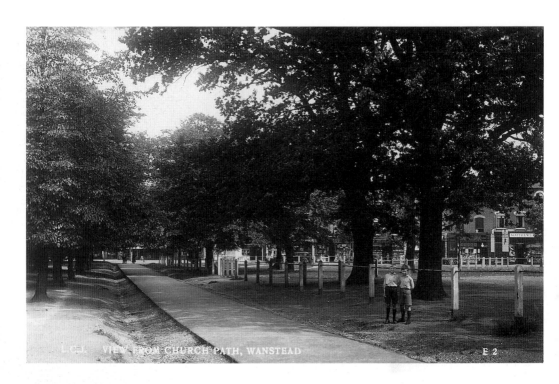

L.C.J. VIEW FROM CHURCH PATH, WANSTEAD E 2

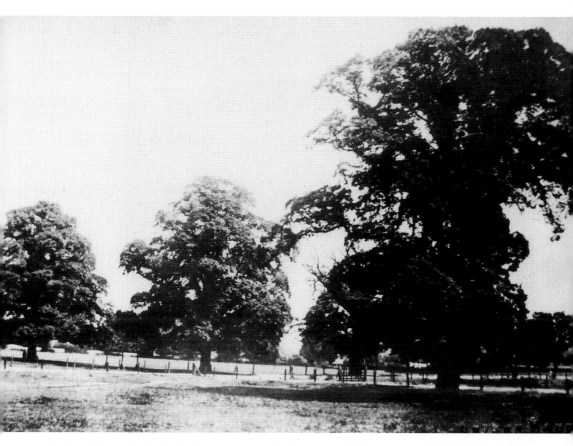

A view of Grove Park and the Avenue prior to development, *c*.1880.

Opposite above: A view from Church Path towards the High Street, *c*.1920.

Opposite below: The ancient walnut tree in Church Path, *c*.1924. On the extreme right is Wanstead Fire Station, Wanstead Place which at this time was manned by volunteers, who were still using horse-drawn carriages. The station officer was Charles William Goldstone.

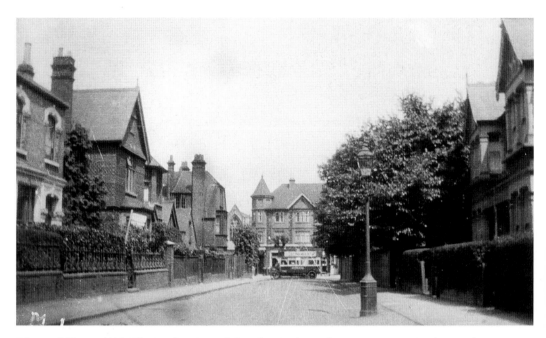

Wanstead Place, c.1922. The London General Omnibus in the High Street is passing Barclays Bank, managed at the time by Frank Hubert Francis.

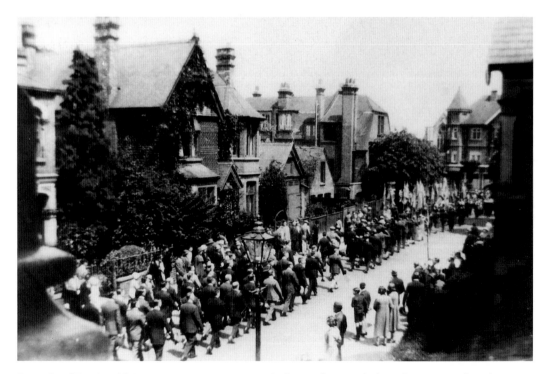

A parade of First World War veterans seen in Wanstead Place as they march from the Town Hall to the War Memorial in the High Street, c.1930.

The view north towards Wanstead Place from Christ Church's yard, *c*.1925. The rear of numbers 2–8 Wanstead Place appear on the right.

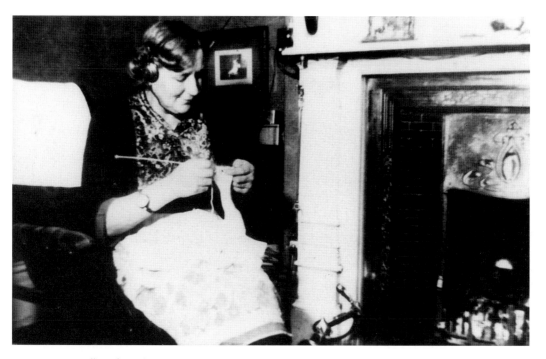

Mrs H Miller of number 2 Wanstead Place listens through headphones to a favourite radio programme on her crystal set, *c*.1930. This one-valve receiver had an aerial leading from the house to a pole at the end of the garden.

The south side of Wanstead Place, *c.*1932. The end house, 'Daisy Bank', at number 2 was one of four
built by Stewarts of Walthamstow in 1914.

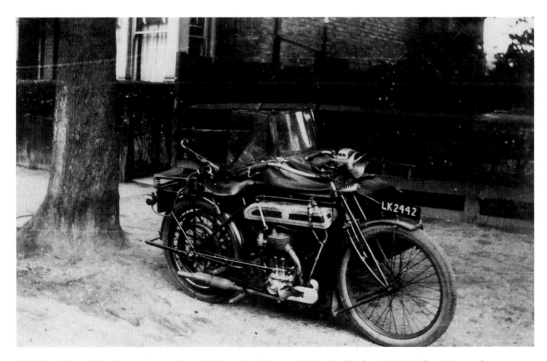

A Triumph combination motorcycle and sidecar in Wanstead Place in the late 1920s. The whitewash
on the tree was part of the blackout precautions used during the First World War air raids. The ladder
chained to the fence was used to service the street gas lamps.

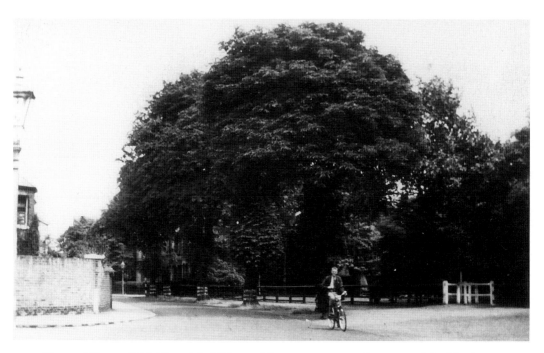

Wanstead Place, *c.*1948. The original Wanstead Rectory appears on the extreme left while the rings around the chestnut trees are remnants of Second World War blackout precautions.

Looking east towards the High Street from Christ Church's yard, Wanstead Place, *c.*1936.

Left: Wanstead Place, *c.*1930.

Below: Blake Hall Road, May 1897. The two large pillars on the left, which are now listed, marked the former entrance to the Wanstead House estate and now stand on either side of Overton Drive. The house 'Park House', the former home of Sir John Bethell, is also just visible. The house was demolished after damage during World War Two.

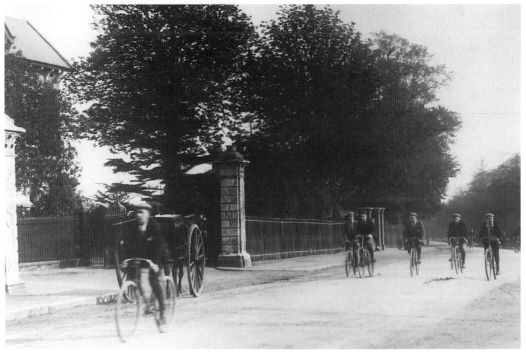

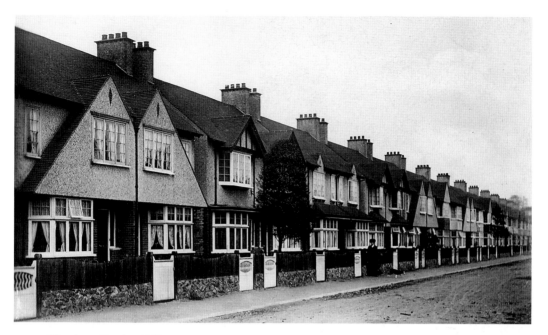

Woodcote Road, *c.*1920.

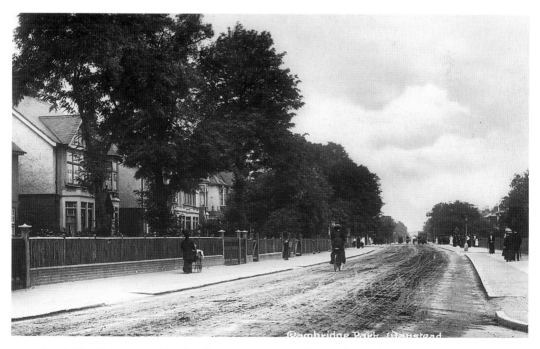

Cambridge Park, the road leading from Leytonstone to Wanstead High Street, *c.*1918.

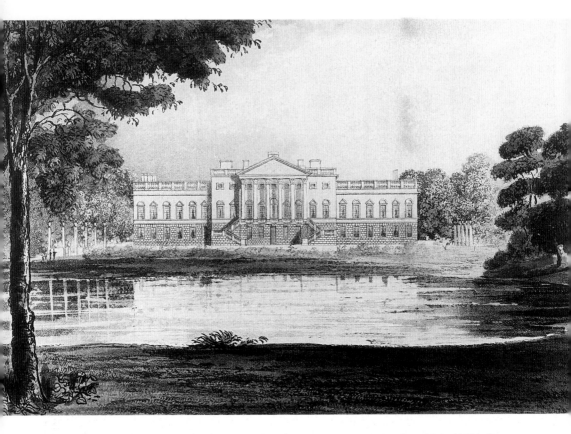

A view of the west front of Wanstead House, taken from an engraving printed on 1 May 1824. Sir Richard Tynley had the house built to Colen Campbell's design between 1715 and 1722 to replace a seventeenth-century house. The Palladian mansion was last owned by William Tylney Long and was dismantled and sold in 1823 to cover its owner's gambling debts. The landscaped grounds contained many ornamental features which survive today as part of Wanstead Park.

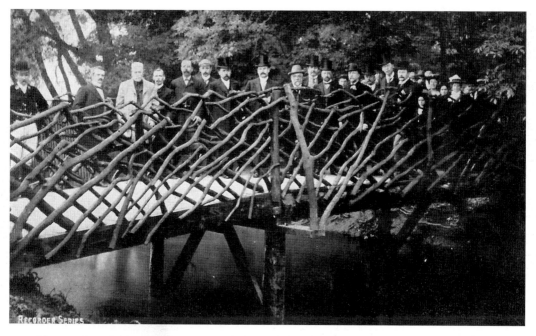

The opening of the ornamental bridge over the Roding from Ilford to Wanstead Park, *c.*1905.

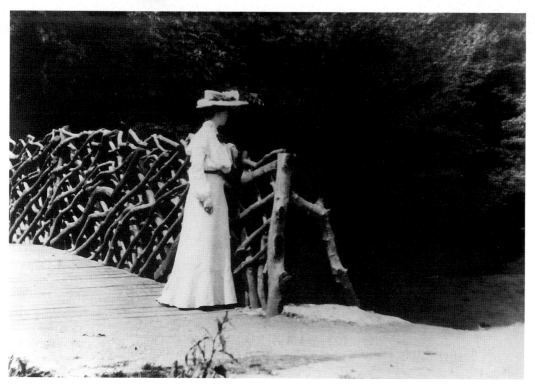

A local resident looks upstream from the new Roding Bridge.

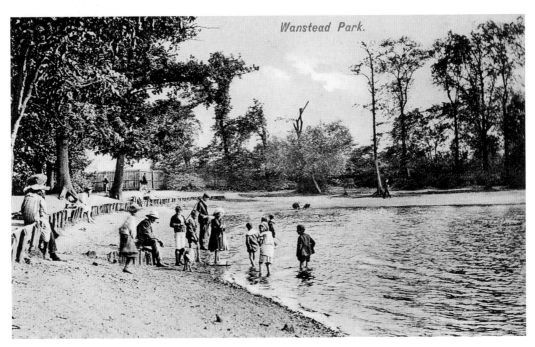

One of the ornamental lakes of the former Wanstead House, *c.*1907.

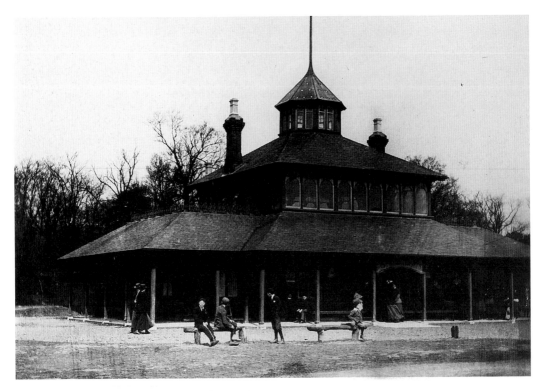

The refreshment pavilion in Wanstead Park, *c.*1910.

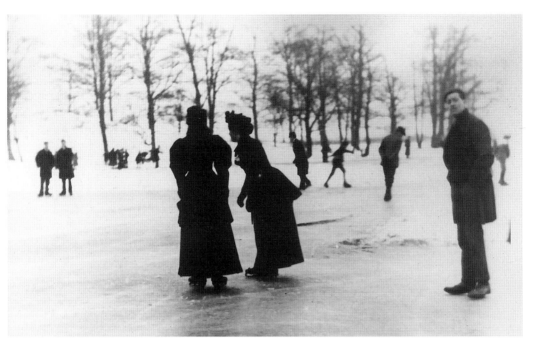

Ice-skating on a Wanstead Park pond, 12 February 1895.

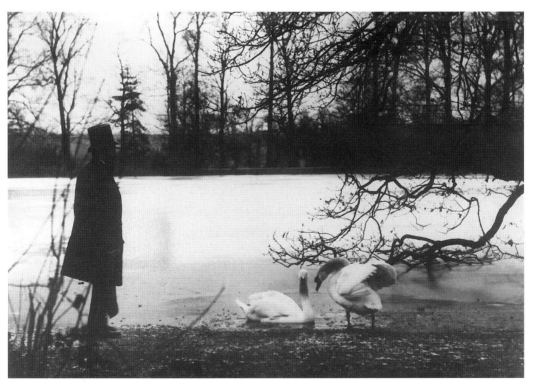

Feeding the swans by a lake in Wanstead Park a month earlier.

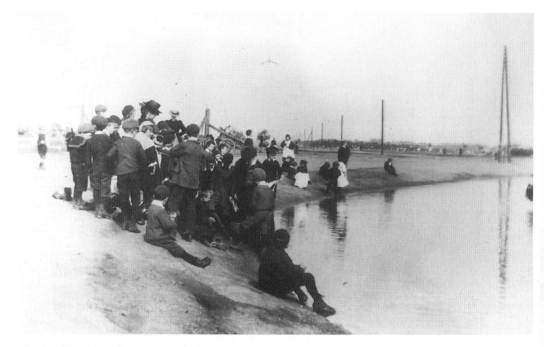

The Capel Road pond on Wanstead Flats, 1897, which was popular with bathers and model boat enthusiasts.

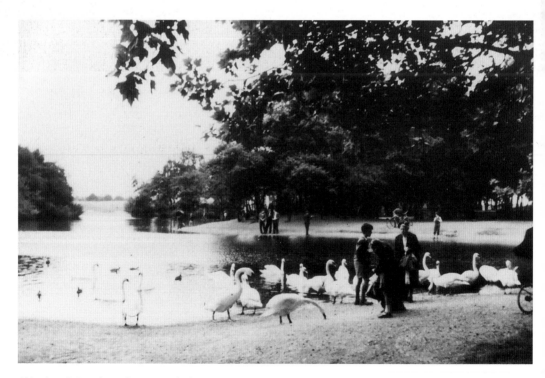

Aldersbrook Road pond, Wanstead Flats, c.1948.

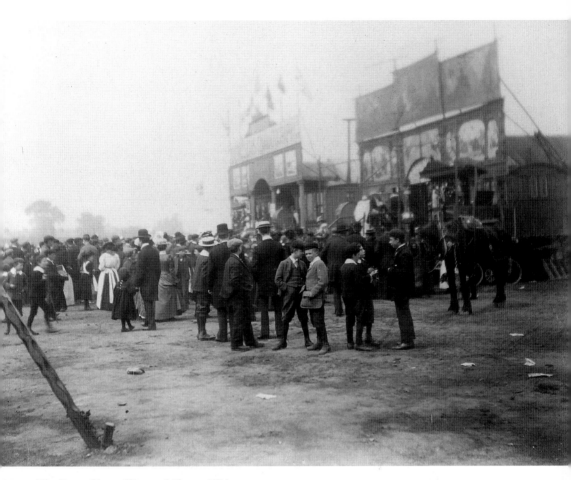

The Easter fair on Wanstead Flats, *c.*1901.

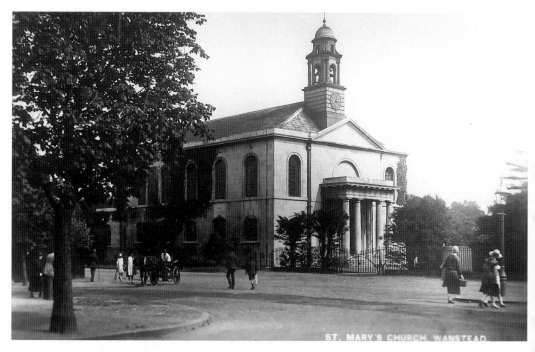

St Mary's Church, Overton Drive, c.1920. This parish church was rebuilt by Thomas Hardwick between 1787 and 1790 and is now the only Grade I listed building in the Borough of Redbridge.

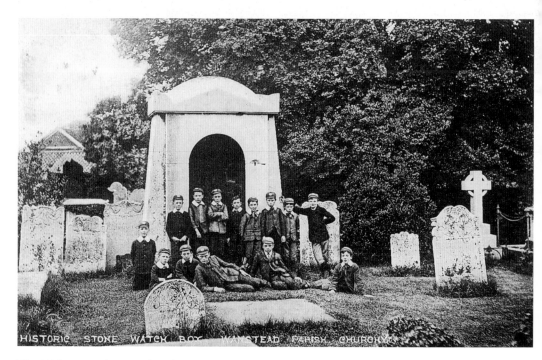

The 1803 memorial to Joseph Wilton in St Mary's churchyard. Wilton (1722–1803) was a sculptor and a founder member of the Royal Academy. This view dates from 1901.

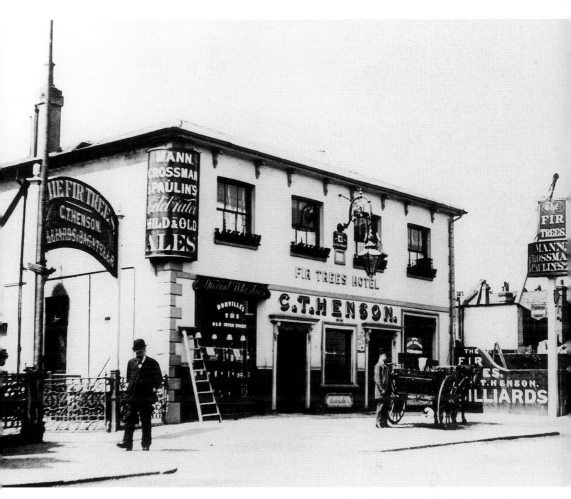

The Fir Trees Hotel, Hermon Hill, *c.*1900. The land at the rear of this early–nineteenth pub was used as a sports ground by Wanstead Cricket Club in the 1860s. The club moved into part of the former grounds of Wanstead House near St Mary's Church in 1879.

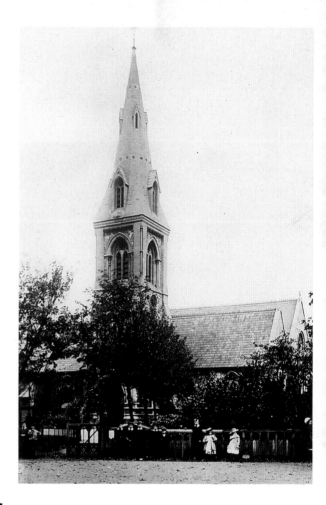

Christ Church in the High Street, *c*.1910. Designed by Sir George Gilbert Scott, it was built in 1861 as a chapel-of-ease to St Mary's.

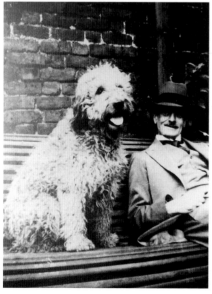

Mr Holford, the organist and choirmaster of Christ Church with his dog in the garden of number 2 Wanstead Place, *c*.1933.

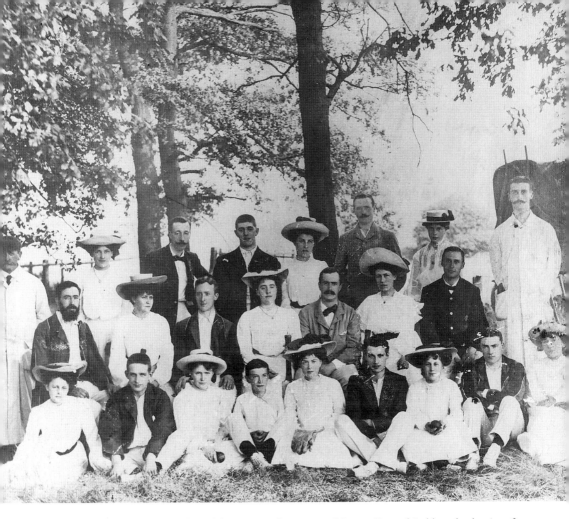

Members of the Wanstead Cricket Club, *c.*1900. The Wanstead Sports Ground Ltd bought the site of Wanstead House in 1920 from Earl Cowley. The site included the lake and stables, both of which were incorporated into Wanstead Golf Club.

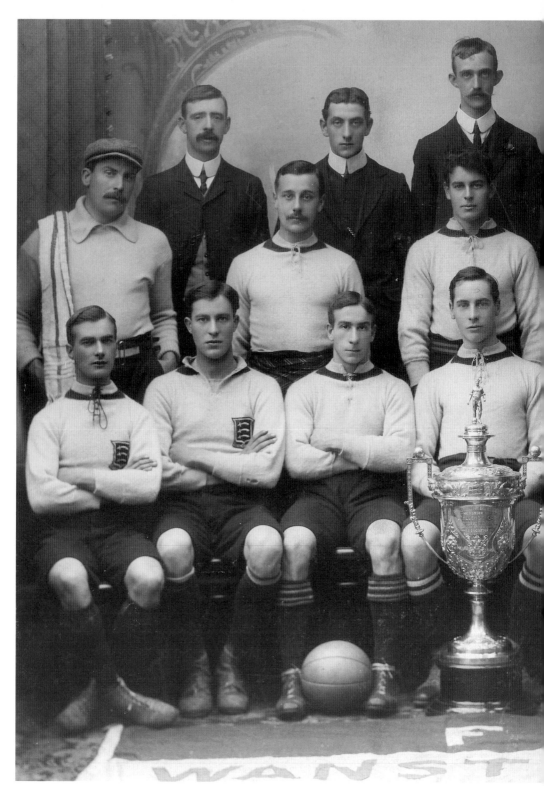

Players and officials of Wanstead
Football Club with the Essex
Senior and West Ham Charity
Cups, 1906.

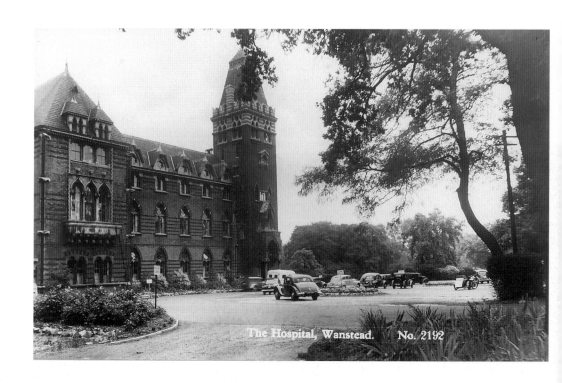

The Hospital, Wanstead. No. 2192

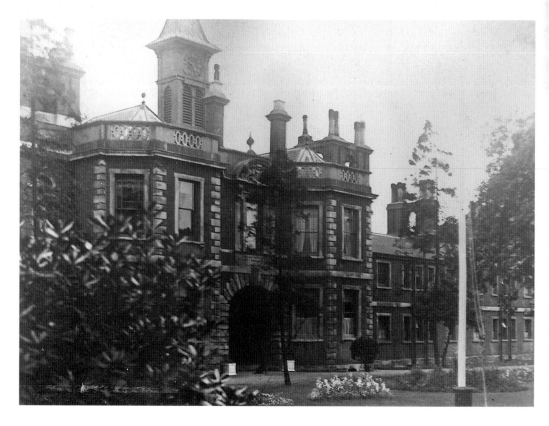

Little Blake Hall, 1 January 1893. This is now the site of number 2 Seagry Road. The adjacent Blake Hall estate, with its much larger red-brick mansion from 1609, was sold for development from 1909.

Opposite above: Wanstead Hospital, Hermon Hill, *c.*1950. Designed by G.C. Clarke, it was opened as the Merchant Seaman's Orphan Asylum in 1861. It was bought by the Convent of the Good Shepherd in 1900 and became a hospital in 1937, when acquired by Essex County Council.

Opposite below: Weavers Almshouses, New Wanstead, *c.*1931. These were originally built in 1857 for the Weavers Company to Joseph Jennings' design. They were rebuilt in 1975, retaining their original appearance.

Wanstead Church of England School, High Street and Church Path. This watercolour from around 1850 shows the 1840 headmistress' house in the foreground with the original 1796 school room on the left. The first headmistress of the school was Miss Townsend.

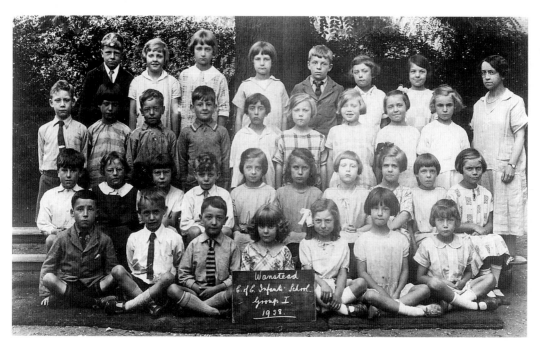

Wanstead Church of England Infants School Group 1, 1928.

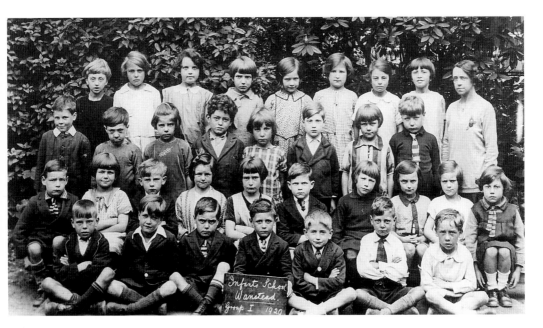

The next year's intake of students to the school.

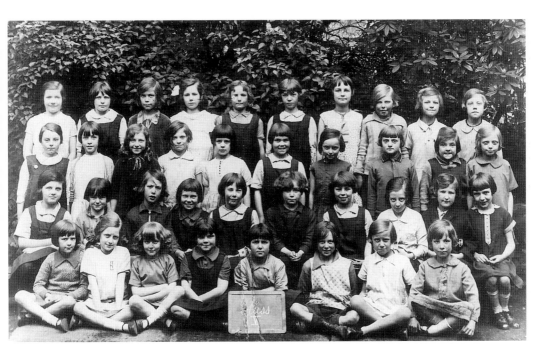

Class 5 in the 1920s.

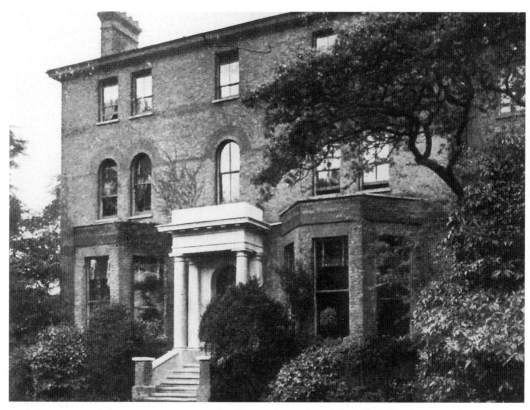

Gowan Lea School, High Road, c.1930. The original headmistresses and owners were Misses Gowlett and Freeman, hence its name. This private school amalgamated with Wanstead College in 1933 and closed in 1970.

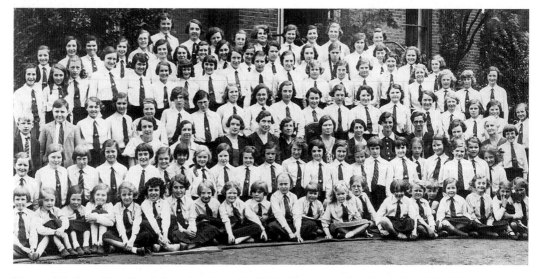

Wanstead College, High Road, Snaresbrook, in the 1930s. The joint college heads were Mrs E.B. Martin and her daughter, Miss Pauline B. Martin. The college was closed in mid-1935 for demolition in November and the site is now covered by Hermitage Court and Flats, built in 1936.

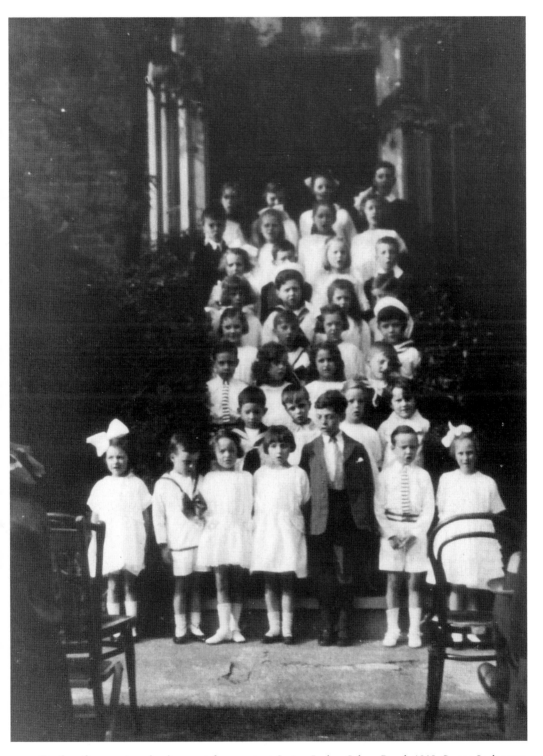

Pupil performers at a school concert for parents at Seaton Lodge, Sylvan Road, 1918. Seaton Lodge was a kindergarten run by the four Crouch sisters.

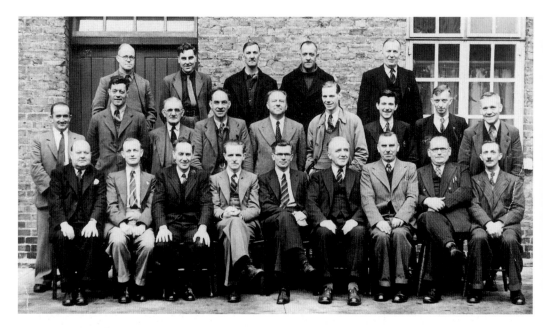

Employees of the Wanstead Telephone, New Wanstead and Gordon Roads, *c*.1950. The foreman, Arthur Hope, is seated on the extreme left of the picture and the four men seated on its extreme right were TV licence inspectors.

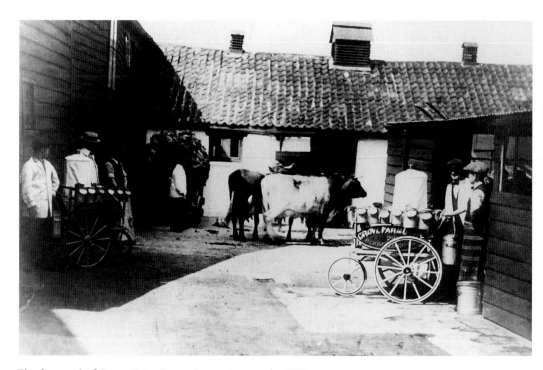

The farm yard of Grove Dairy Farm, George Lane in the 1920s.

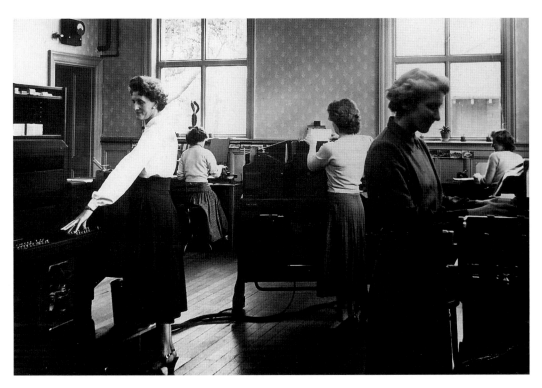

The machine section at Snaresbrook House, Woodford Road, c.1957. This early-nineteenth-century mansion was purchased by Wanstead and Woodford Council in the early 1950s and was used by the Borough Treasurer's department.

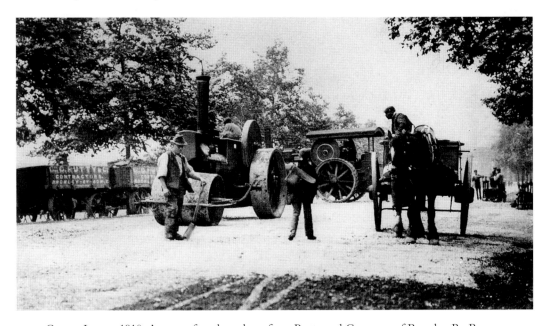

George Lane, c.1910. A party of road-workers, from Rutty and Company of Bromley-By-Bow, resurface the road. Steam road-rollers and traction-engines remained in use into the 1950s.

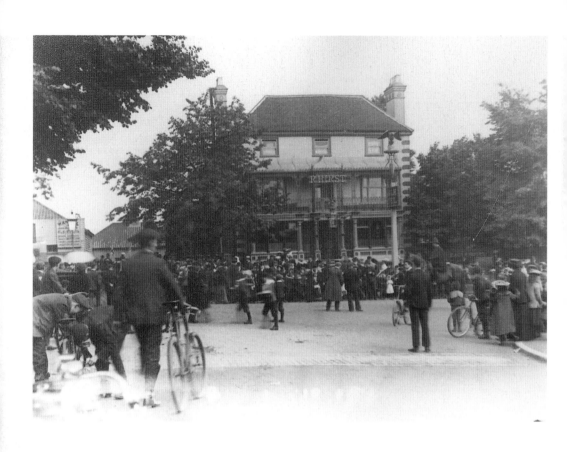

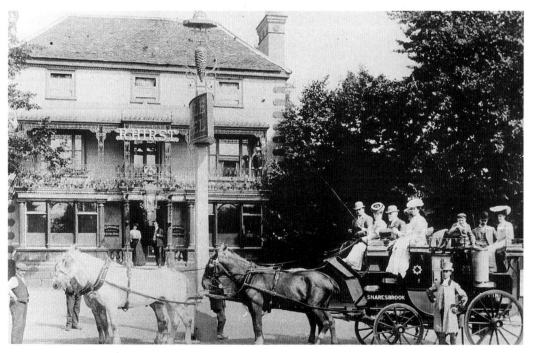

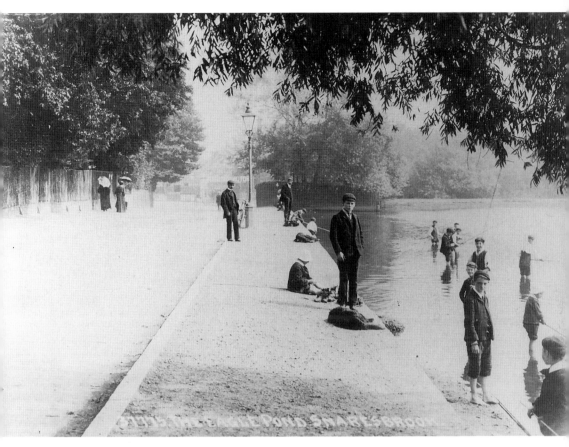

Eagle Pond, Snaresbrook, *c.*1917. It has been a popular place for anglers since the eighteenth century. An 1831 guidebook described Snaresbrook as a 'naturally pleasant and healthy neighbourhood, highly improved by art, which has been selected as a suitable situation for numerous elegant seats and country villas'.

Opposite above: The crowds gather to watch the procession of the Woodford Cyclists Meet pass outside the Eagle Hotel, Snaresbrook, *c.*1900.

Opposite below: The Eagle Hotel by Woodford Road, *c.*1900, where the stage-coach recreates a scene from the 1820s. The 'Spread Eagle' originated in the late 1600s, becoming an important coaching inn between 1780 and 1820.

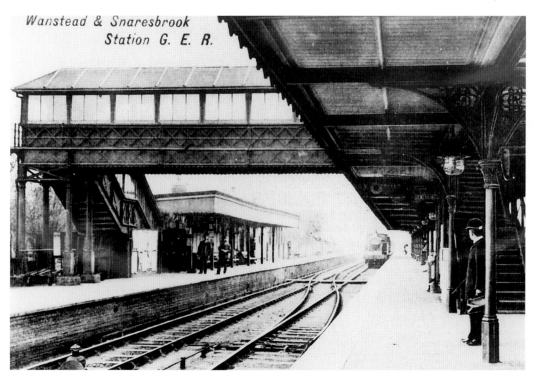

Wanstead and Snaresbrook Station, which was later called just Snaresbrook Station, *c*.1905. This section of the line to Ongar was opened by the Great Eastern Railway in 1856.

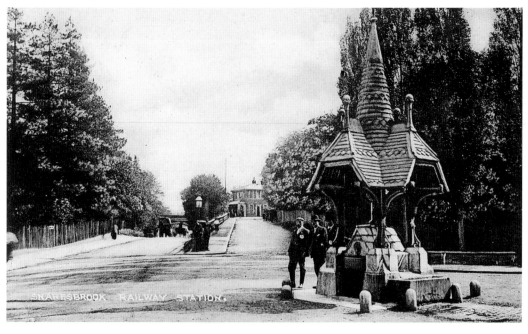

Station approach and the High Street by Snaresbrook Station in the late 1940s. The rebuilt Central Line opened on 12 December 1947.

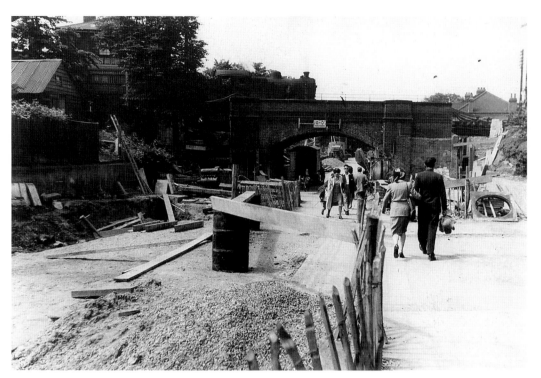

The High Street by Snaresbrook Station looking north during reconstruction work, *c.*1945.

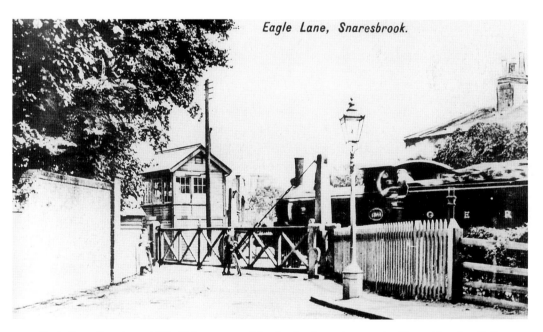

Eagle Lane, Snaresbrook.

Eagle Lane Crossing, *c.*1905. This was one of the five level crossings on the 'Central London Railway Line' which was renamed the Central Line in 1937. The gates were removed in 1948, Eagle Lane was bridged and a pedestrian subway was provided.

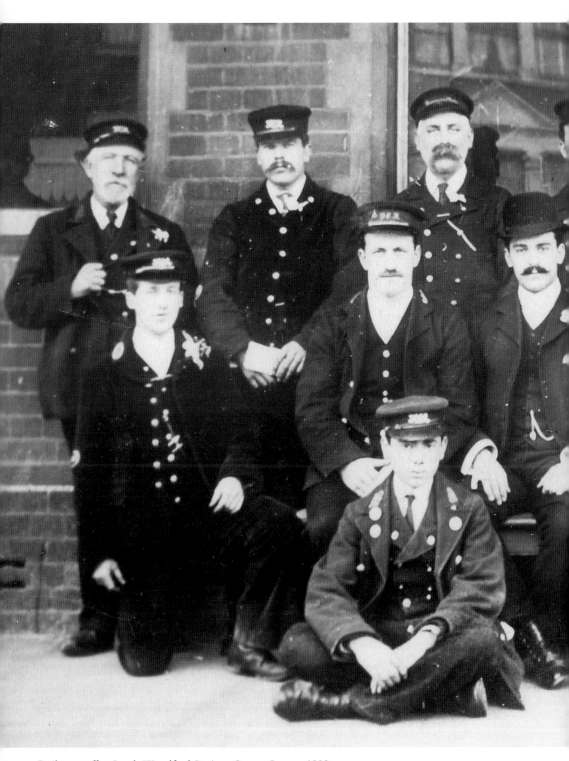

Railway staff at South Woodford Station, George Lane, *c*.1909.

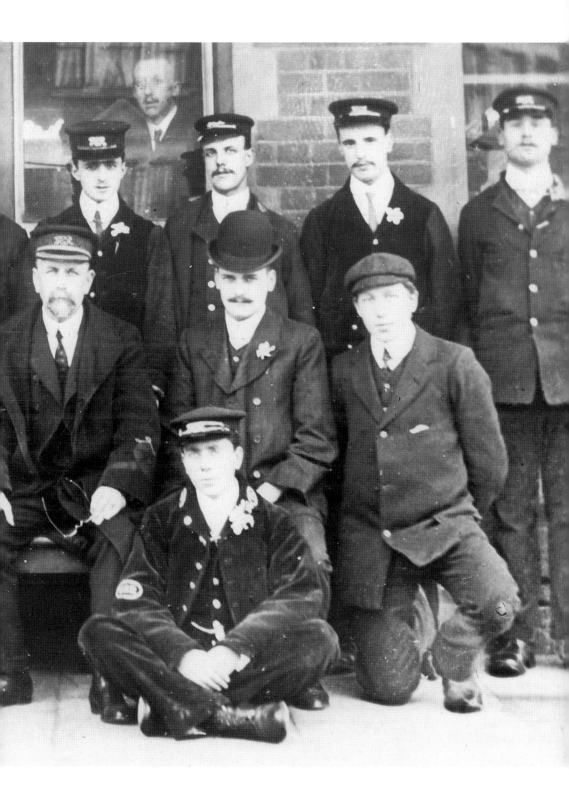

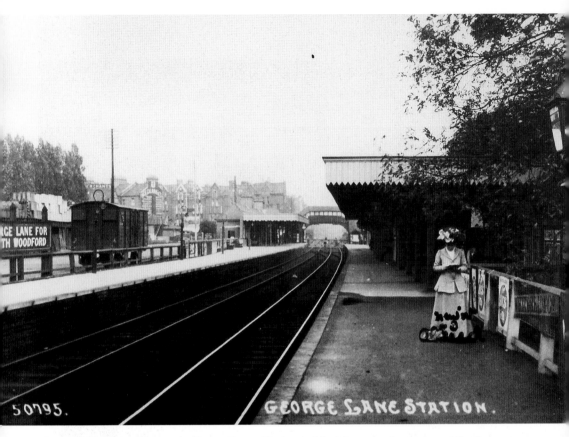

This Great Eastern station on the line to Ongar, Epping and Loughton was later renamed South Woodford. This view from 1905 shows the waiting rooms which were segregated into a general and a ladies room. The train service was irregular with some morning trains running non-stop from Snaresbrook to Liverpool Street.

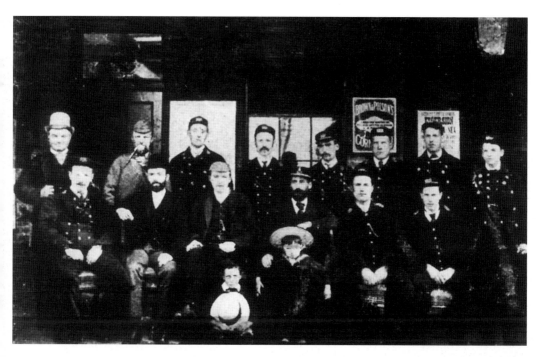

Woodford Station railway staff, *c.*1888.

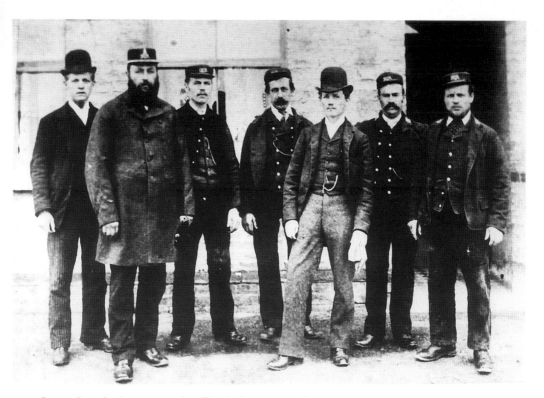

George Lane Stationmaster and staff in the late nineteenth century.

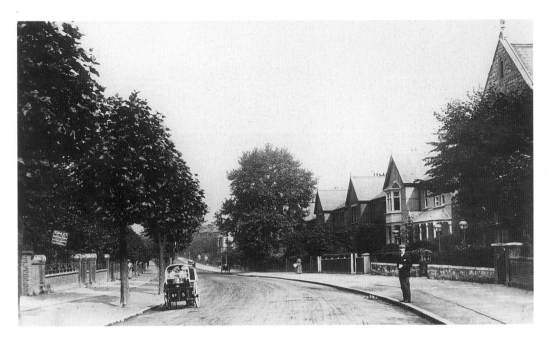

Hermon Hill, Wanstead, *c.*1910.

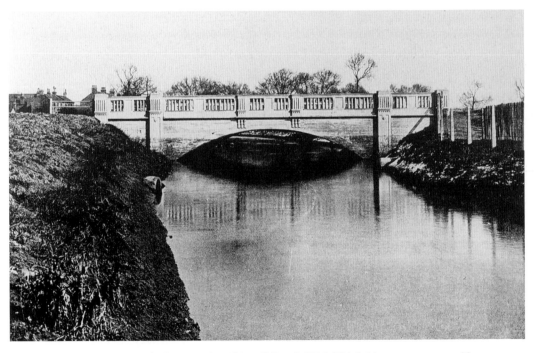

The Roding Bridge on Woodford Avenue by Chigwell Road, 1924. This bridge was constructed by W. and C. French between 1923 and 1924, using the Hennebique system of reinforced concrete. It was the part of the London to Southend arterial road scheme known as the Woodford Spur, later renamed Woodford Avenue.

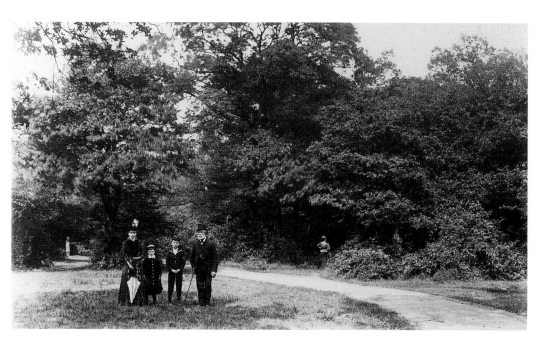

A family outing to Epping Forest at Snaresbrook on Saturday 13 June 1891.

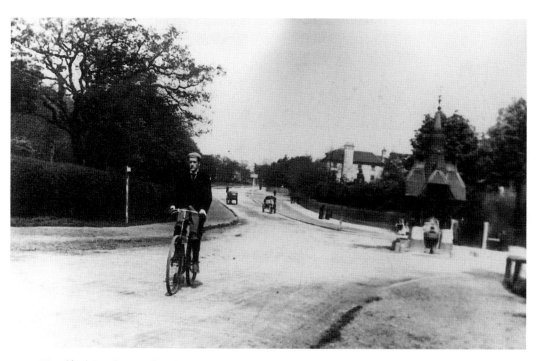

Woodford Road, Snaresbrook, 1898. This view looks north from Holly Bush Hill towards the Eagle Hotel. The wooded grounds behind the fountain belonged to Valley Lodge, a mid-nineteenth-century mansion.

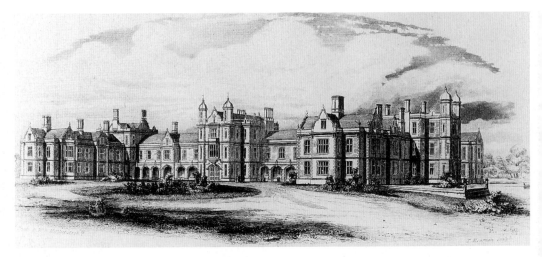

A design from 1841 for the Infant Orphan Asylum, Holly Bush Hill in Snaresbrook. The asylum was opened on 5 June 1843 by Leopold, King of the Belgians, and the architects were Gilbert Scott and William Moffat. Given the royal blessing in 1918, it was renamed the Royal Wanstead School in 1938 and closed in 1971. Snaresbrook Crown Court now occupies the buildings.

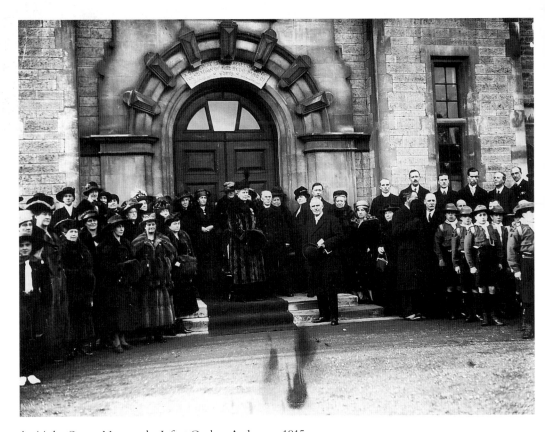

A visit by Queen Mary to the Infant Orphan Asylum, *c.* 1915.

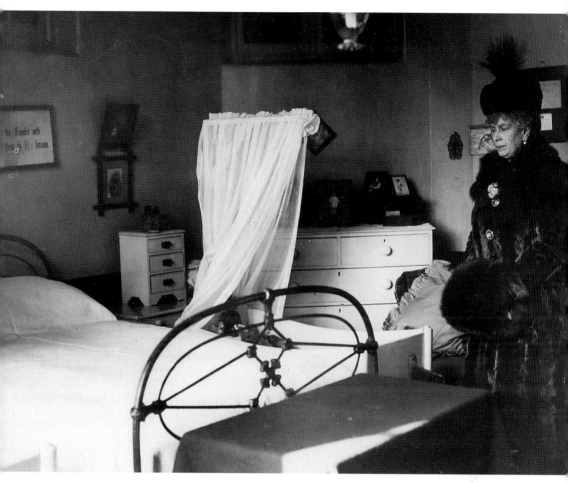

Queen Mary inspecting a bedroom at the Infant Orphan Asylum during her visit.

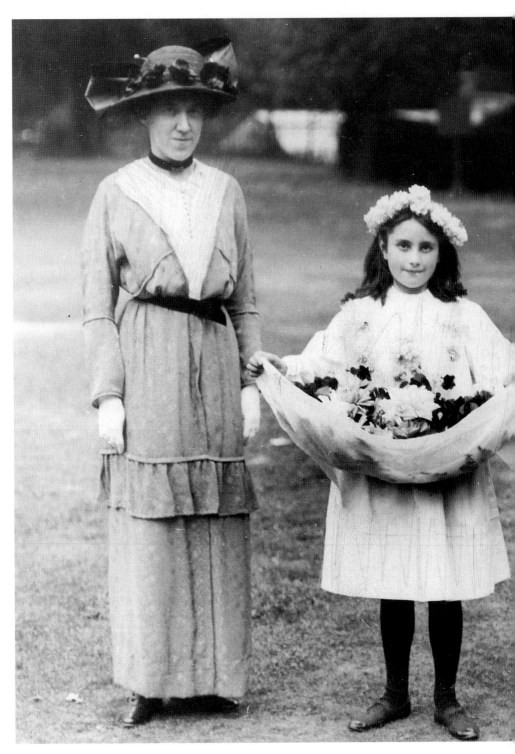

Prize day at the Infant Orphan Asylum, *c.*1900. Left to right: Miss Britton, Headmistress, Alice Wheeler, a pupil with bouquets for Lady Landsdowne and Sir George Truscott.

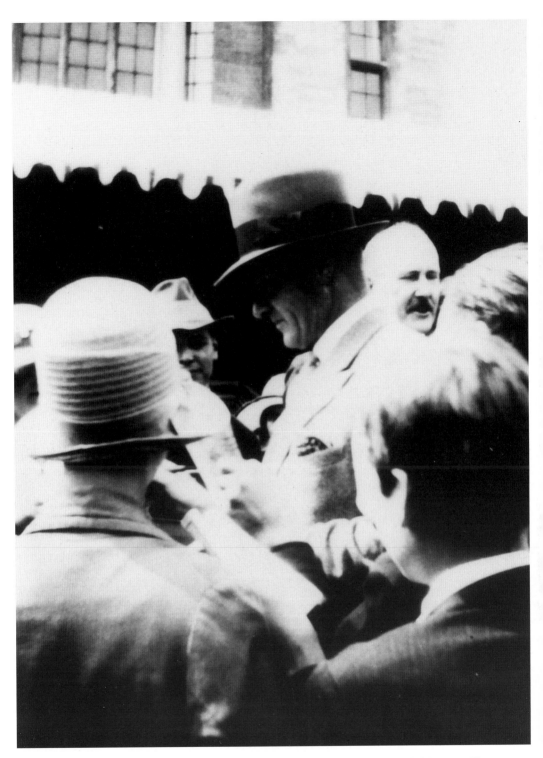

Malcolm Campbell, the pioneer racing driver and father of world land-speed record holder, Donald Campbell, signing autographs at an Infant Orphan Asylum fête, *c.*1928.

two

Woodford

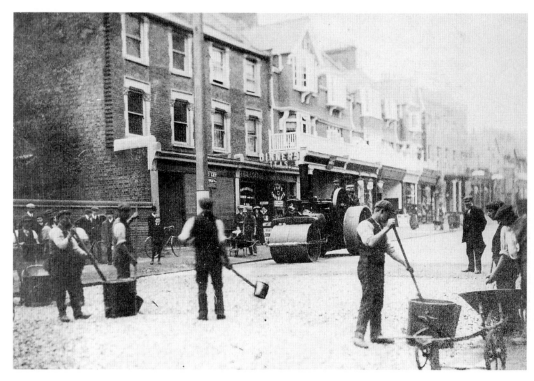

Repairing the High Road, *c.*1899. The White Hart public house can be seen in the distance.

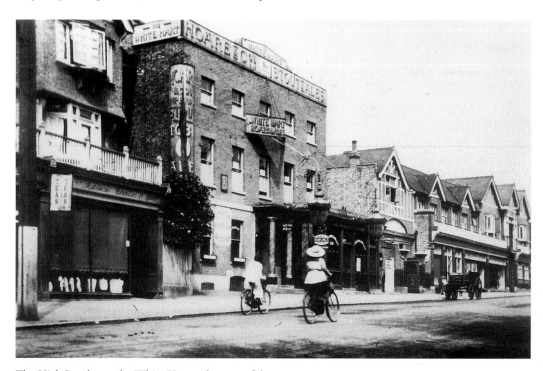

The High Road near the White Hart at the turn of the century.

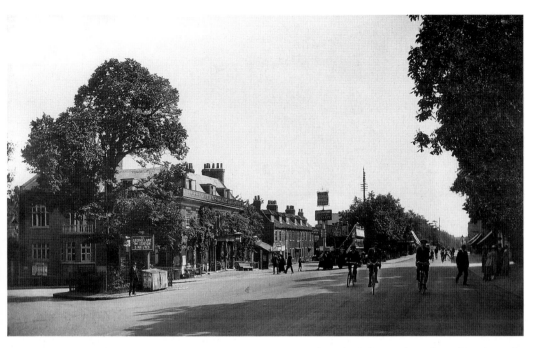

The High Road by George Lane, *c.*1920. The George Hotel on the left dates from the early eighteenth century. The adjacent eighteenth-century terraced houses were demolished in the early 1930s to make way for the Majestic Cinema.

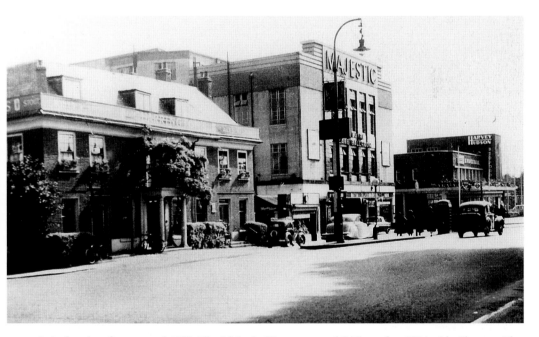

A similar view from around 1950. The Majestic Cinema opened 5 November 1934 with *Cleopatra*. The architect, S.B. Pritlove, provided seats for 2,000 people. The Majestic was 'tripled' in 1972 and became the ABC in 1973, retaining all three screens.

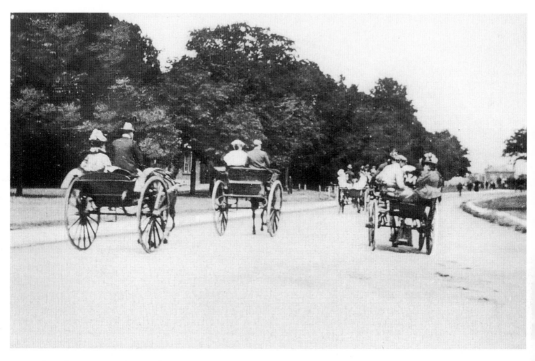

A Sunday afternoon on the High Road, Woodford Green, *c*.1910.

By the Castle Hotel on the High Road, Woodford Green, *c*.1925. On the left can be seen the reading room of the Working Men's Institute (also see page 70).

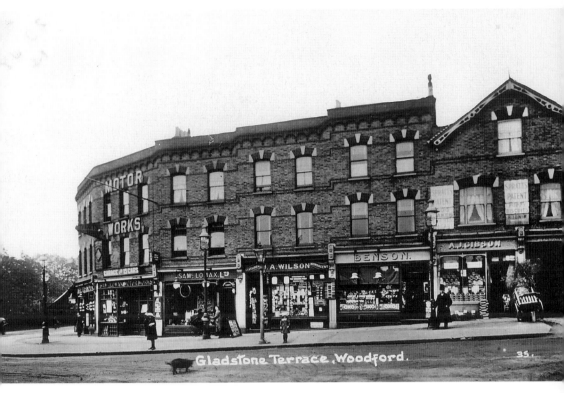

Gladstone Terrace, 6–10 High Road, by Derby Road, *c*.1914. The shops include, from left to right: Samuel Lomay, motor engineer, John Alfred Wilson, stationers, and the post and annuity office, George Benson, game dealer, and A.J. Gibson, corn and flour merchants.

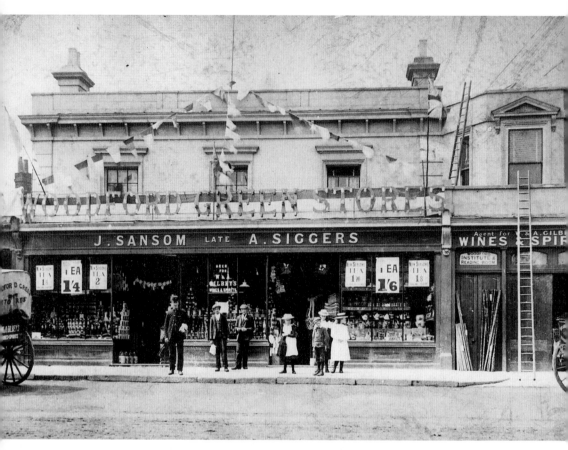

The Woodford Green stores of J. Sansom and A. Siggers, north of the Castle Hotel on the High Road, *c.*1897. The doorway to the left of the ladder led to the Woodford Working Men's Institute and Reading Room. The latter was open to members every weekday evening from 6.30 to 10.30. The secretary at this time was G. Bryant.

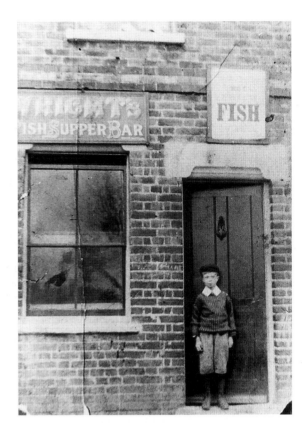

Right: Wright's Fish Supper Bar, 5 Castle Yard, Mill Lane, Woodford Green, *c.*1900.

Below: W. Ketts' cab at its rank outside the Castle Hotel, High Road, Woodford Green, *c.*1883.

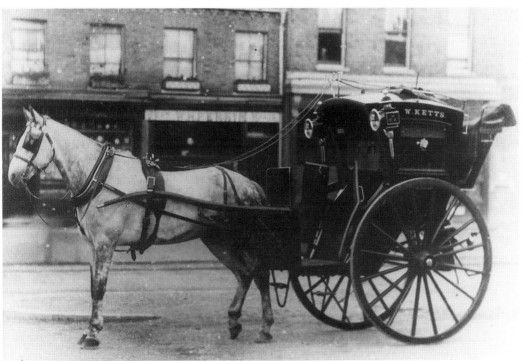

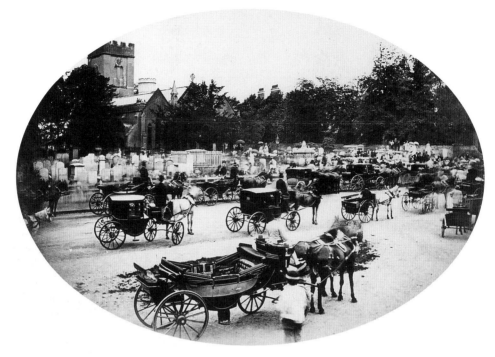

Carriages wait for a wedding party at St Mary's Parish Church, High Road, Woodford Green, *c*.1880.

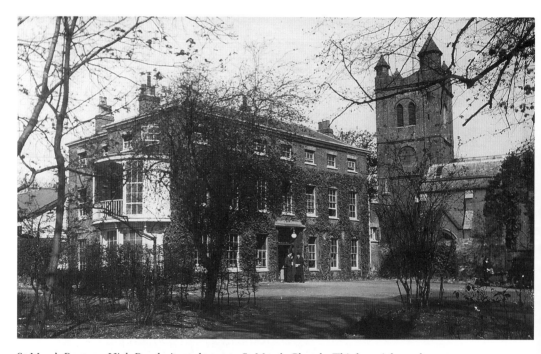

St Mary's Rectory, High Road, situated next to St Mary's Church. This late-eighteenth-century building became the offices for the new Borough of Wanstead and Woodford in 1937. Woodford Crown Court occupied the building from 1968 to 1988.

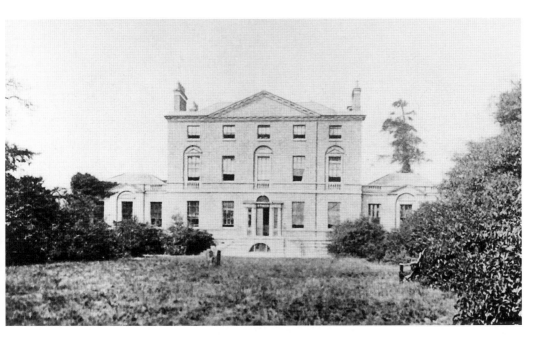

The main façade of Woodford Hall, High Road, c.1880. This was originally a fifteenth-century house but was rebuilt between 1630 and 1640. The designer William Morris lived there as a child from 1840 to 1848. Demolished around 1900, its site is now partly occupied by St Mary's Church Memorial Hall.

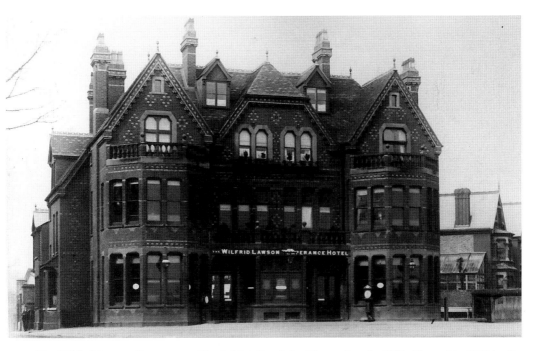

The Wilfred Lawson Temperance Hotel, High Road, by Charter Road, c.1891. Opened in 1883 by Sir Wilfred Lawson MP (1829–1906), by 1951 it had become a nurses training centre. In 1974, amid local controversy, it was demolished and replaced by apartments.

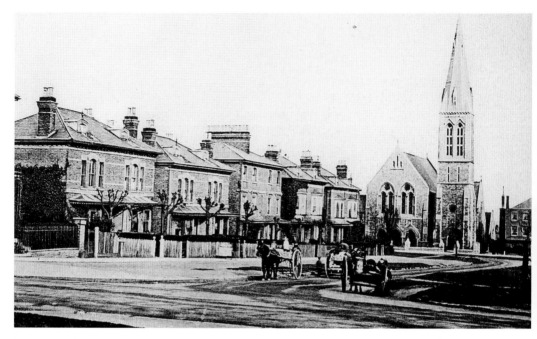

'The Terrace' in Woodford Green with the Congregational Church in Broomhill Road, *c.*1900. The church was built in 1837 but severe damage from two V1s in 1944 led to its demolition in 1946. The Sir James Hawkey Hall was opened on the site in 1955.

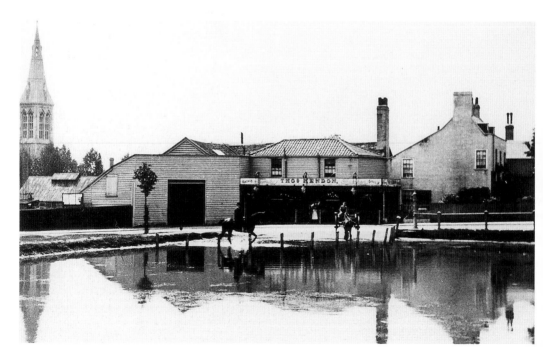

Kendon's Pond, Woodford Green, *c.*1900. Thomas Kendon's butcher's shop can be seen facing the pond while the Congregational Church is visible on the left.

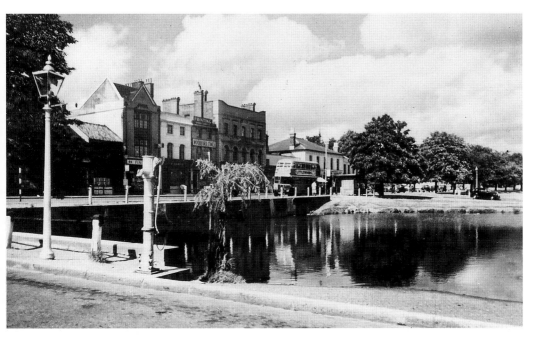

The High Road by Kendon's or Hasler's Pond, *c.*1955. The pond was named after the butchers mentioned in the previous picture.

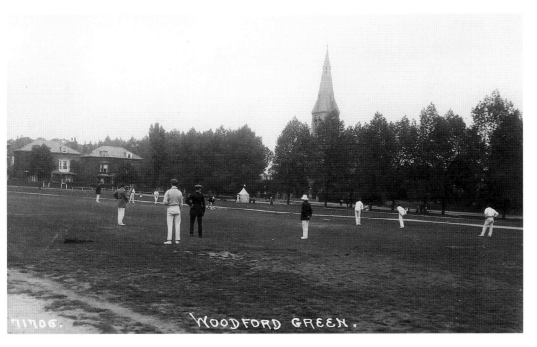

Woodford Green, *c.*1912. Part of 'The Terrace' and the spire of the Congregational Church are visible behind the men preparing to play cricket.

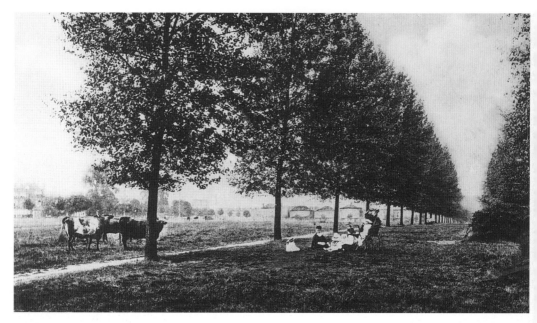

Woodford Green looking north towards 'The Terrace', *c.*1904. The family in the foreground only have a herd of grazing cows for company.

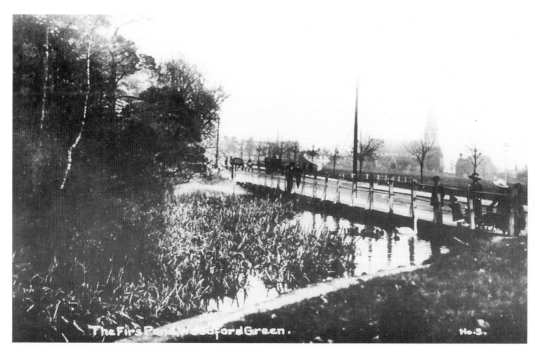

The Firs Pond, Woodford Green, *c.*1913. The pond, which was formed by gravel extraction in the nineteenth century, was known by many names. The Firs Estate was at one time occupied by Andrew Johnston (Johnston's Pond) and more famously Richard Warner of Harts House (Warner's Pond). The spire of All Saints Church in Inmans Row can be seen in the distance.

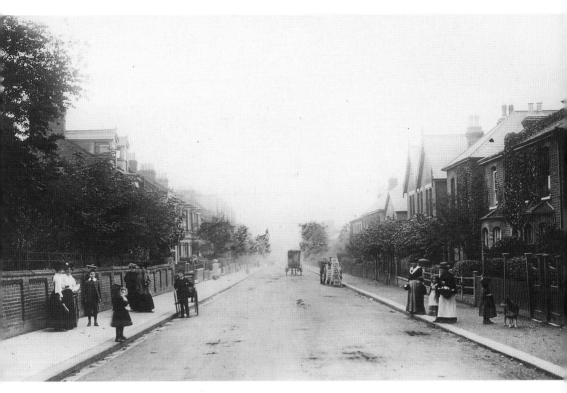

Maybank Road, South Woodford, *c.*1909.

Salway Hill, Woodford Green, *c.*1920. The number 10 bus is heading for Loughton.

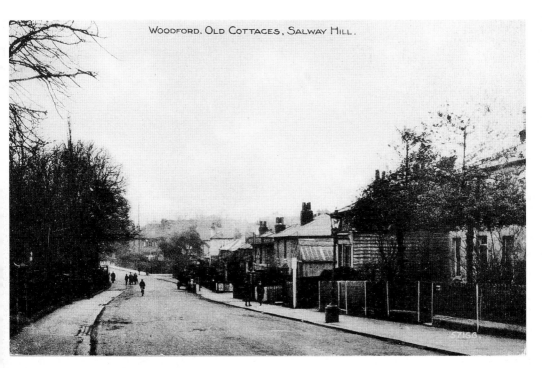

Old cottages, Salway Hill, Woodford, *c.*1910.

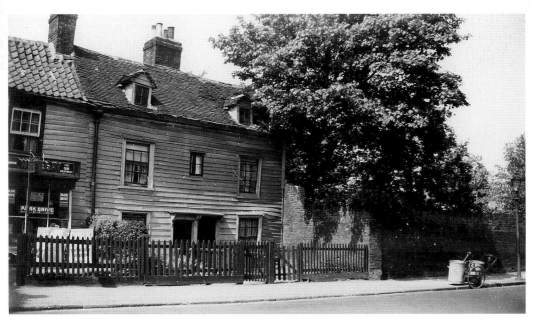

Salway Hill, *c.*1930. These cottages were demolished in 1935 to be replaced by Austin House. A double row of weather-boarded cottages were situated back-to-back along Fullers Road and Salway Hill.

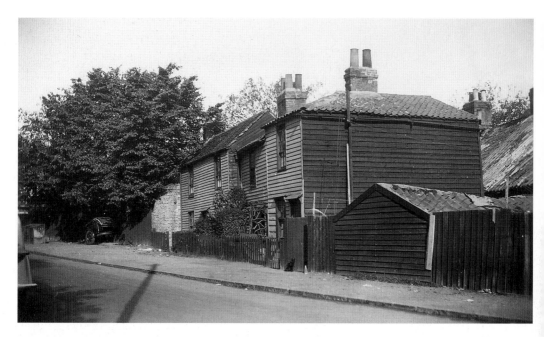

Fullers Road, Woodford, c.1949. These eighteenth-century cottages, backing onto Salway Hill, were demolished by 1951.

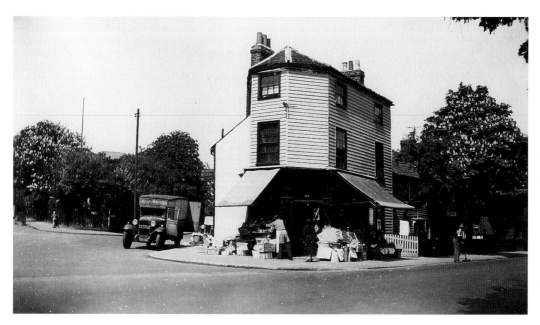

The corner of number 152 Salway Hill and Fullers Road, c.1930. This greengrocer's shop, which was occupied by J.C. Ellis and later by 'Nears', was demolished in 1955.

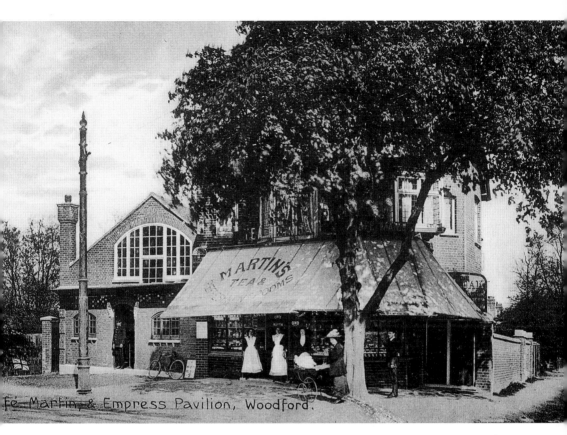

Café Martin and Empress Pavilion, Woodford New Road, situated between Empress Avenue and
Fullers Road, *c.*1915.

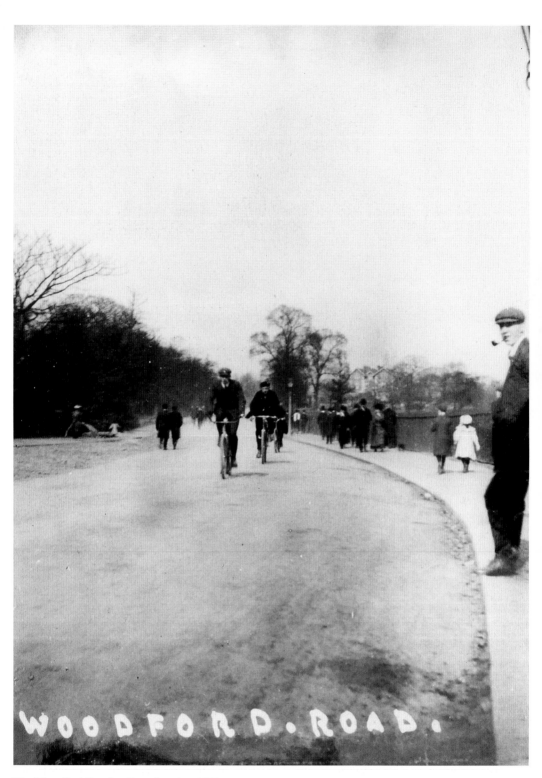

The Woodford Road at Snaresbrook, *c.*1900.

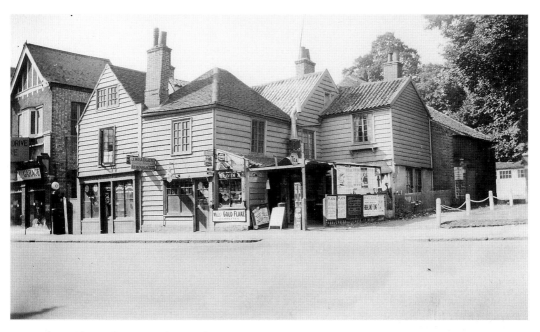

The High Road, *c.*1930. These eighteenth-century weather-boarded shops next to St Mary's Rectory were demolished in 1972. The neighbouring gabled block was replaced by retirement flats in 1987.

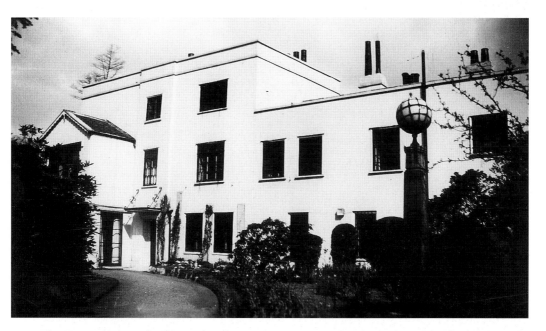

The Hermitage, an early-nineteenth-century mansion, in Snaresbrook Road, *c.*1930. After heavy bomb damage the building was demolished for a post-1945 housing estate.

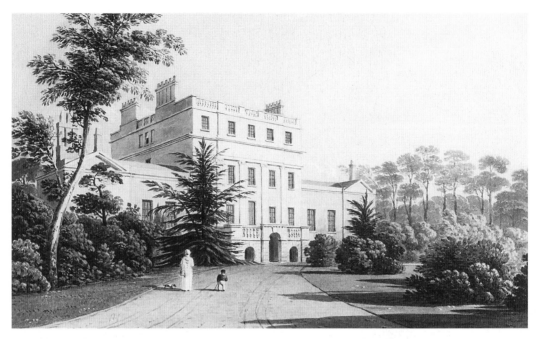

'Highams', 1820. The seat of Jeremiah Harman and John Varley, it was built in 1768 by William Newton with grounds laid out by Humphrey Repton.

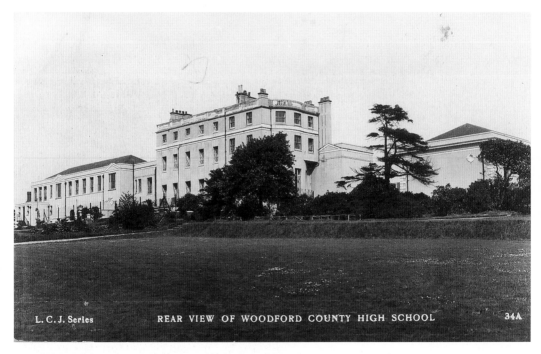

L.C.J. Series · REAR VIEW OF WOODFORD COUNTY HIGH SCHOOL · 34A

The former house and grounds of 'Highams' in the High Road, Woodford, became the Essex County Council High School for Girls in 1919. Extra wings were added to the north in 1928 and the south in 1938. The Woodford and Waltham Forest boundary passes through the grounds.

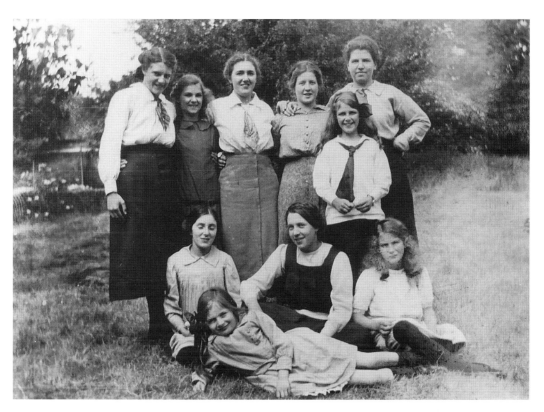

Above: Staff and pupils of Essex House School, Woodford, *c.*1920s. Formerly the seventeenth-century Grove House in Broomhill Walk, the building was partially rebuilt in 1832 to become Essex House School but was destroyed during the Second World War.

Right: Domestic staff at Essex House School at the same time

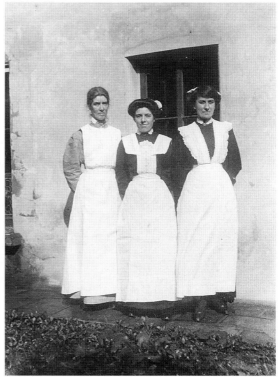

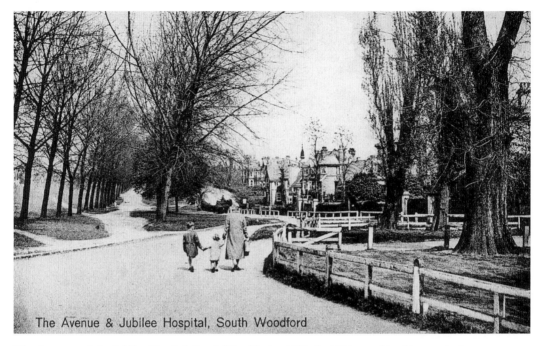

The Avenue and the Jubilee Hospital, South Woodford, *c*.1920. In 1924 a marble chip mosaic floor was laid in the hospital's operating theatre by Italian workmen to reduce static during the use of anaesthetics.

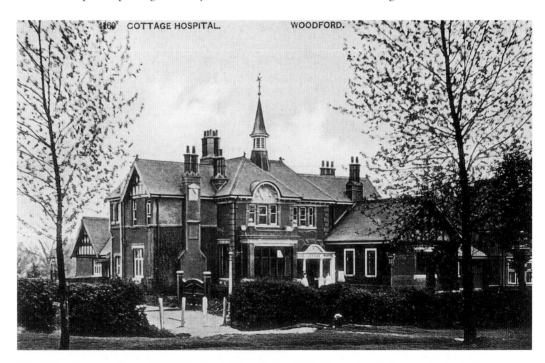

The Jubilee Hospital, Broomhill Walk, South Woodford, *c*.1910. Opened with fourteen beds, the first annual report of 1900 recorded the admission of ninety-one cases, and twenty-one operations were carried out in the theatre.

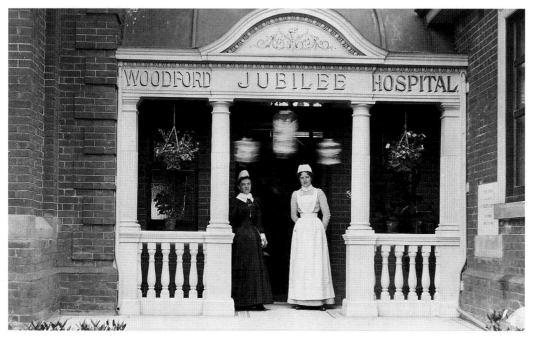

The hospital entrance, *c*.1900. By 1987 the cottage hospital design of the Jubilee had become outdated and the building was closed and later demolished.

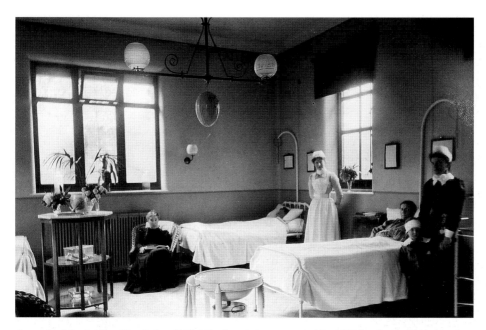

A ward of the Jubilee Hospital, *c*.1900. The hospital was opened in 1899 by the Duke and Duchess of Connaught. It was built to commemorate Queen Victoria's Diamond Jubilee and was the gift of the Stratford draper Sir John Roberts of Salway House. As a memorial to EdwardVII additional wards were opened in June 1911, and a children's ward was opened in 1921. The hospital added X-ray equipment in 1926.

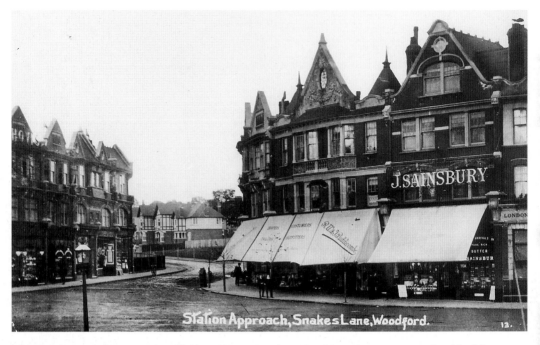

The Broadway, Snakes Lane, Woodford, c.1920s. J. Sainsbury Provisions shop was at number 32 while numbers 30, 31 and 31A were occupied by R.W. and I. Puddicombe, Drapers. At number 33 William Woodard was the manager of Barclays Bank.

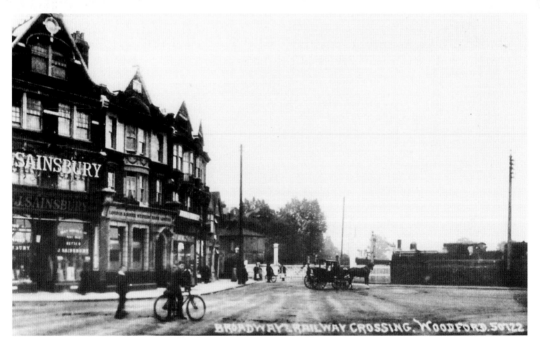

Snakes Lane, Broadway, c.1922. This view looking east towards the railway crossing shows a train at the Woodford Station.

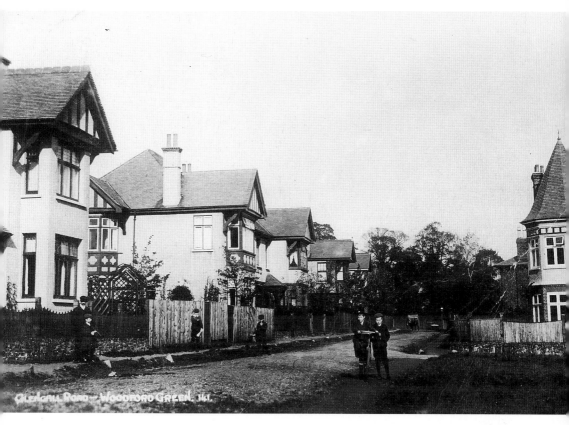

Glengall Road, Woodford Green, *c.*1912. These houses, south of Snakes Lane, were built from 1898 by, among others, Sheppard and Brothers of 13 and 14 Snakes Lane, Woodford. Number 16 was completed on 4 September 1909 for James Charles Phelp.

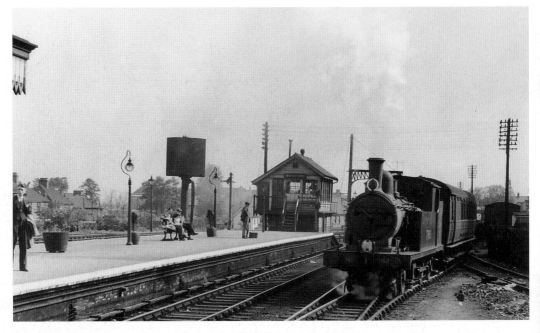

Woodford Station with LNER locomotive 7785 heading a train, *c.*1938. The station opened in 1865 with the completion of Great Eastern Railway's Loughton branch line.

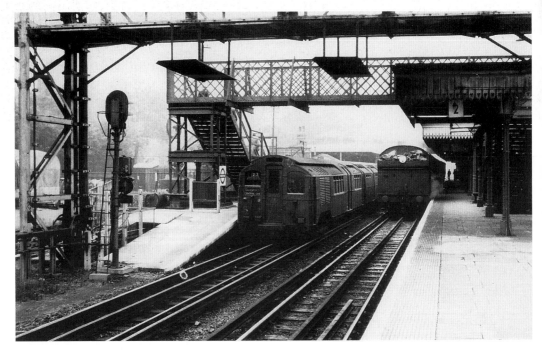

A view from platform 2 of Woodford Station in the early 1950s. The Loughton line was suggested for electrification by the LNER new works programme of 1935. The improvements reached Woodford in December 1947 when the new Central Line opened.

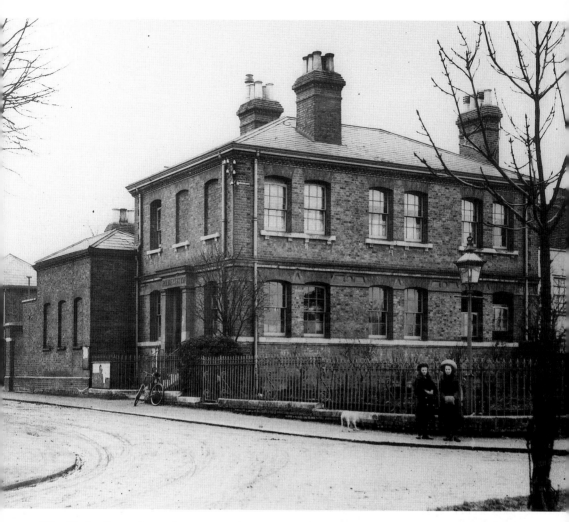

Woodford police station at the junction of Mornington Road and the High Road, *c*.1910. The Woodford gaol stood beside the High Road in front of 'Elmhurst'. The small single-storey building survived until 1928 while the main building was replaced in 1968/9 by a new station further south on the High Road.

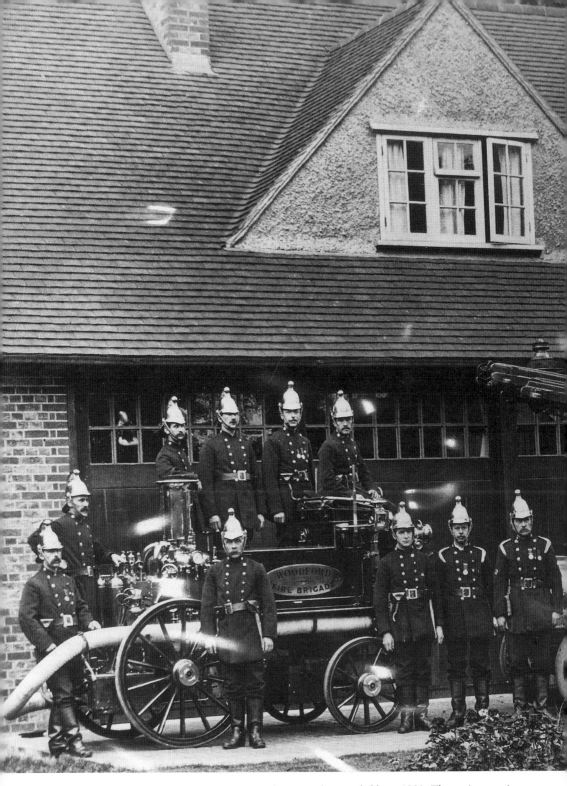

Woodford Fire Station and firemen with their appliances and escape ladder, *c*.1920. The station was in the grounds of 'The Willows' in Snakes Lane. The Superintendant in 1926 was W.J. Cox.

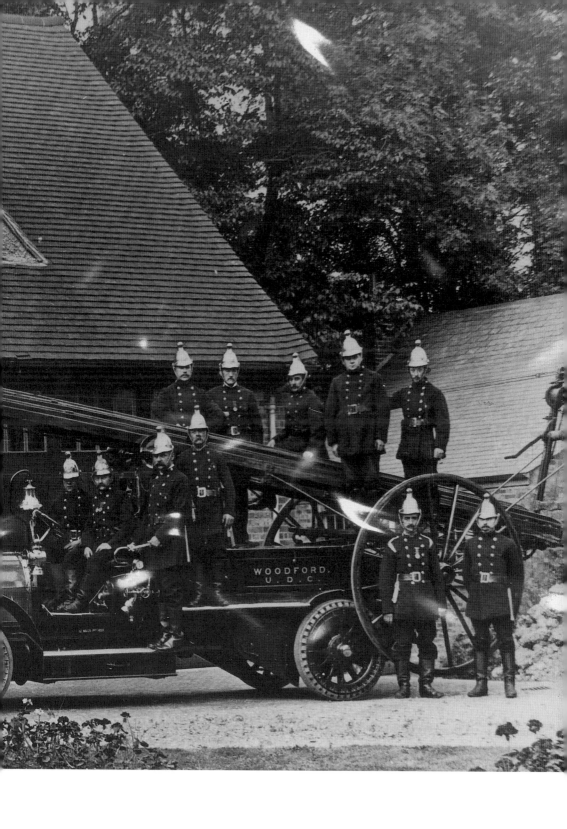

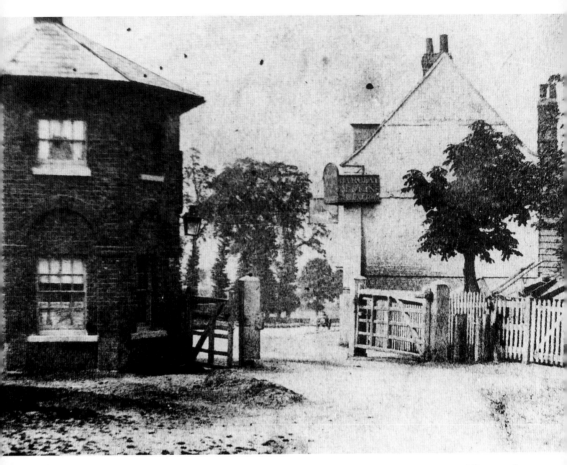

The Tollgate, Woodford Bridge, adjacent to the White Hart public house, c.1860. The Middlesex and Essex Turnpike Trust was set up in 1721 to develop a road from Whitechapel to Woodford. By 1736 it also controlled what later became the Chigwell Road. The Trust built Woodford New Road in 1828 and this was joined with Epping New Road in 1834. Thus a high-class turnpike road running through Woodford was created. Previously Chigwell (or the Lower) Road and the High (or the Upper) Road, Snakes Lane and George Lane were the only through routes in the parish.

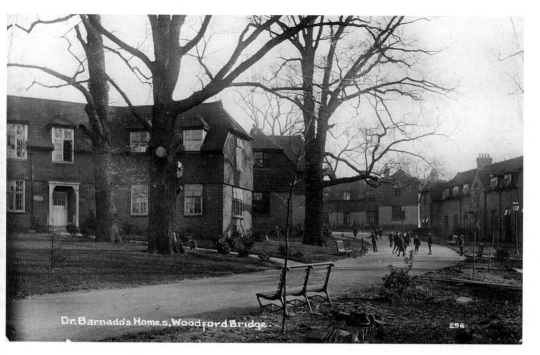

The Dr Barnardo's Village Home for Boys, *c.*1920. The early-nineteenth-century Gwynne House in Manor Road was bought by Barnardo's in 1910 and by 1930 a Village Home for Boys had been developed in the 64-acre grounds.

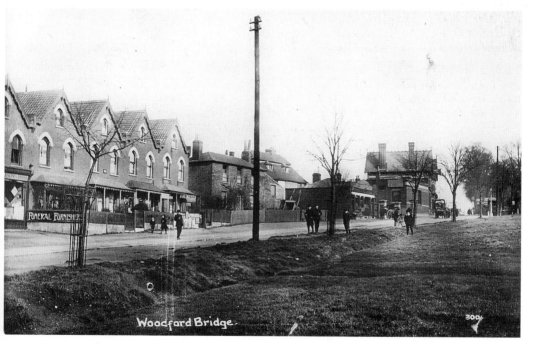

Woodford Bridge, *c.*1917. This view looking along the High Street towards the White Hart illustrates the rural nature of early-twentieth-century Woodford Bridge.

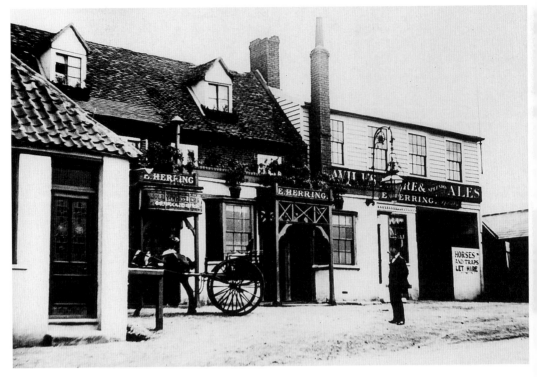

The Jolly Wheelers public house, Woodford Bridge, 1906.

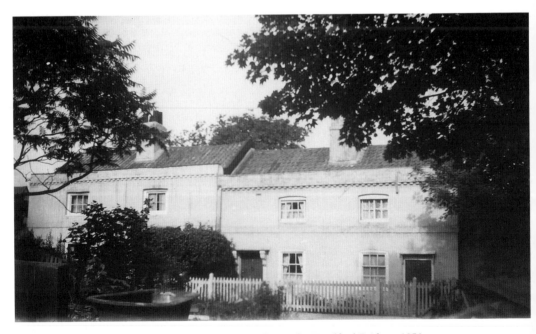

A few cottages opposite the Jolly Wheelers in the High Road, Woodford Bridge c.1950.

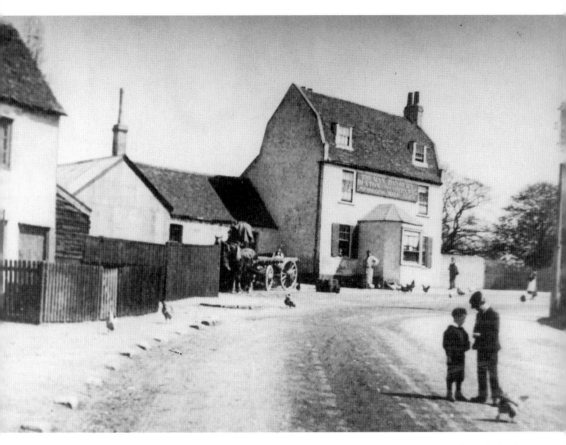

The Crown and Crooked Billet public house in Manor Road, Woodford Bridge *c*.1902. This pub, built in the early-eighteenth century was the village local whereas the nearby White Hart was the main coaching inn in the nineteenth century. The building was leased by Miss Tynley Long for sixty-one years in 1772 at an annual rent of ten shillings.

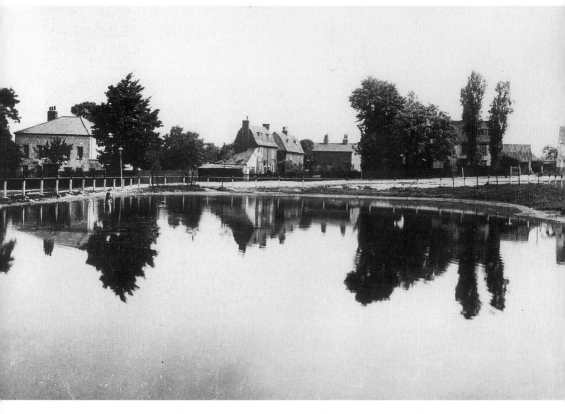

The view across the pond at Woodford Bridge towards the Crown and Crooked Billet, *c*.1912.

Opposite above: The view across the Green at Woodford Bridge towards Manor Road, *c*.1925. The buses have come from the Elephant and Castle.

Opposite below: A westerly view towards St Paul's Church, Woodford Bridge, from near the Crown and Crooked Billet. The London General Omnibus Company bus dates the scene to the 1920s.

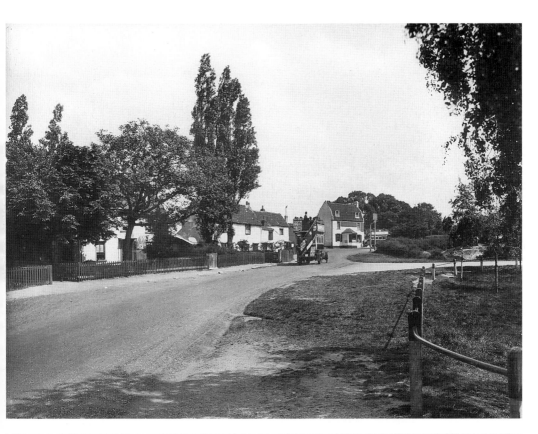

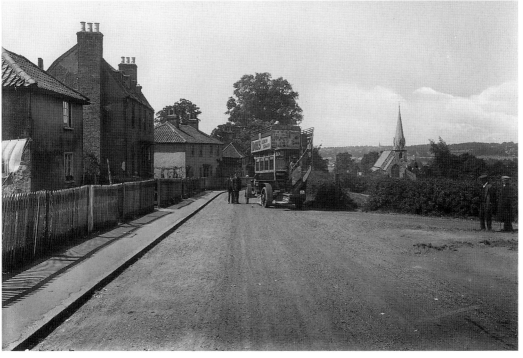

Above: Monkham's Lane on a January day in 1906.

Left: A group of gypsies on forest land in Woodford, *c.*1930.

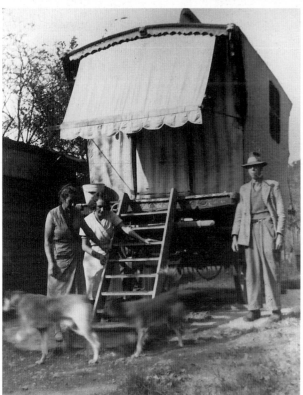

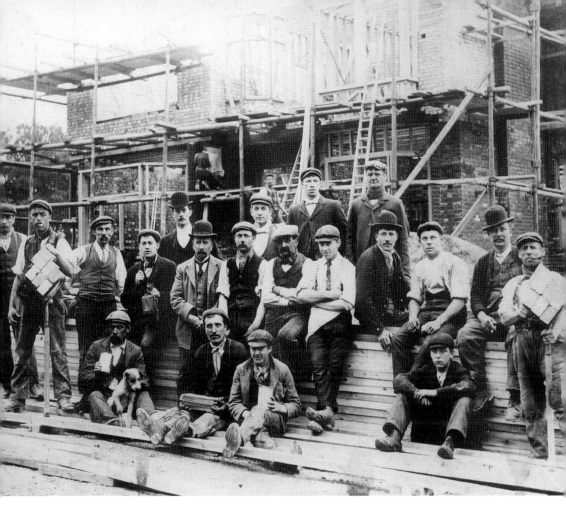

Building workers on the Monkham's Estate, probably the site of Monkham's Drive, *c.*1918. The Estate and Monkham's House were bought in 1903 by James Twentyman for development. The 1738 mansion, situated north of Monkham's Avenue, survived until 1930. Its owners had included the banker Henry Ford Barclay and Arnold Hills of Thames Ironworks fame.

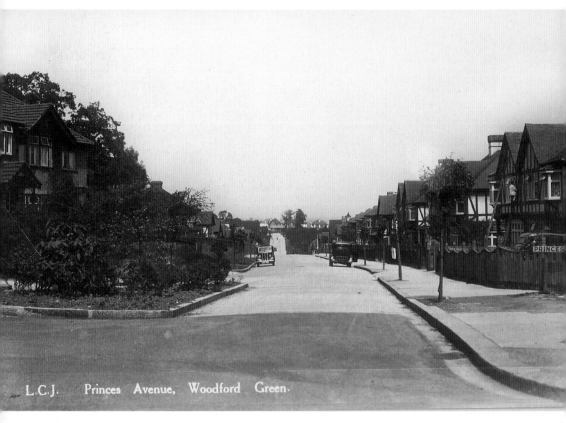

L.C.J. Princes Avenue, Woodford Green.

This view of Princes Avenue, Woodford Green, from the 1930s shows the style of properties built on the Monkhams Estate. The agent for the estate lived at number 9 the former 'Swiss Cottage'. This remained after Princes Avenue was completed.

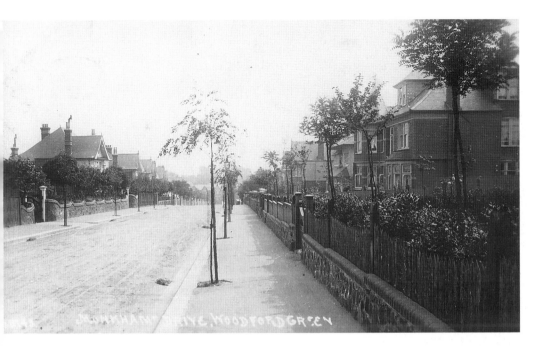

Monkham's Drive, Woodford Green, *c*.1925.

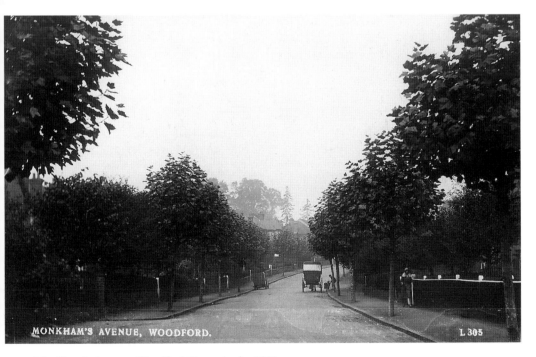

Monkham's Avenue, Woodford Green, in the 1920s.

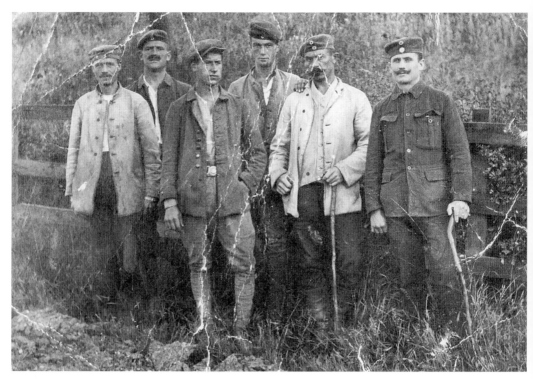

German prisoners of war working as farm labourers on the Monkham's Estate during the First World War.

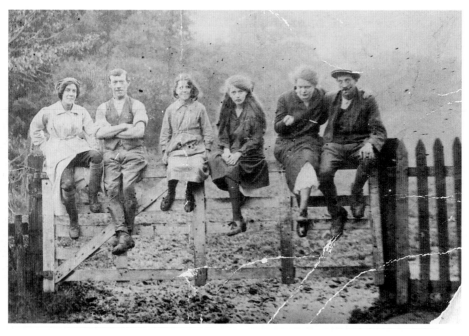

A Monkham's Farm worker's family in Monkham's Lane around 1920.

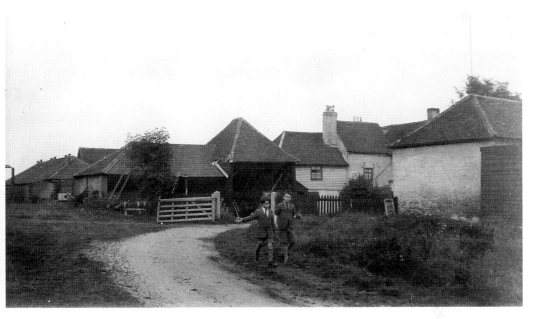

Monkham's Farmhouse and outbuildings, *c.*1925. The farm buildings were at the end of Monkham's Lane next to Little Monkham's House by Knighton Wood.

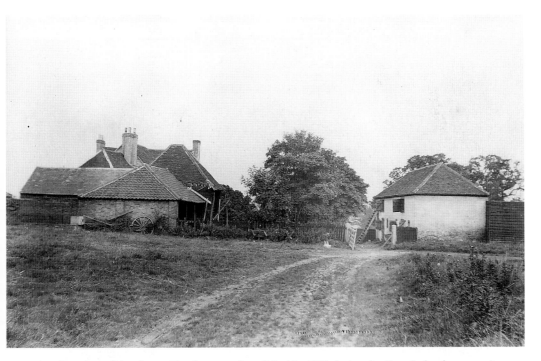

Another view of the above. The farm was demolished in 1936 during the Estate's development. A subsequent Monkham's Farm, known as Home Farm, was situated further up Monkham's Lane near Monkham's House.

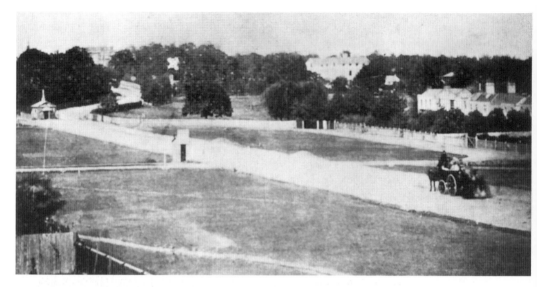

The High Road at Woodford Wells near its junction with Epping New Road, *c.*1862. The village Toll House can be seen on the extreme upper left of this view. This is one of the earliest photographs of the area to have survived.

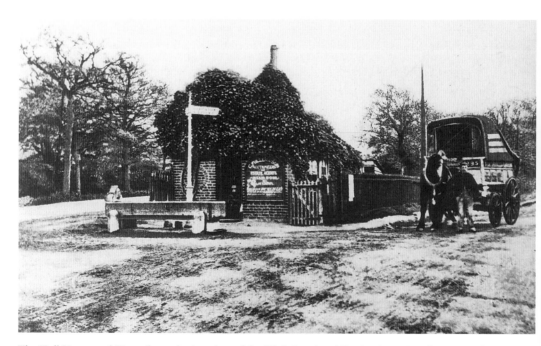

The Toll House and Turnpike at the junction of the High Road and Epping New Road, *c.*1900. The junction was re-aligned in 1935 and 1975 and the horse trough had disappeared by 1964.

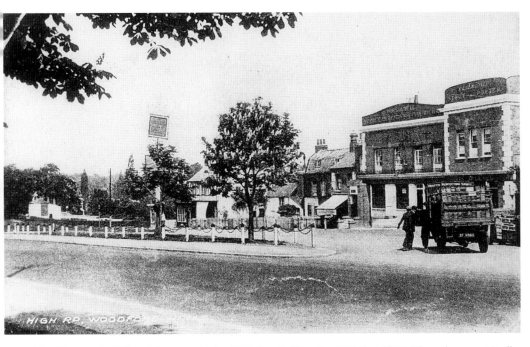

The Horse and Wells public house in the High Road, Woodford Wells, *c*.1922. The pub was originally called the Horse and Groom and was situated near to the 'wells' which were adjacent to the High Road.

Shops and houses by the Horse and Wells, *c*.1954.

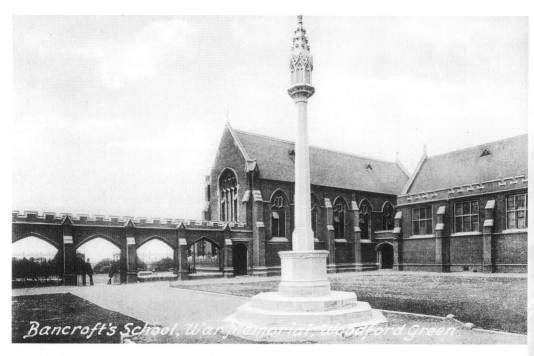

The First World War memorial in Bancroft's School in the High Road, Woodford Wells around 1920.
The school was founded in 1737 and moved to Woodford in 1889. Its new buildings were designed in
Tudor style by Sir Arthur Blomfield.

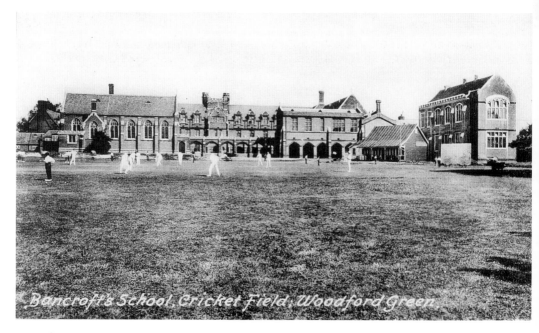

Bancroft's School cricket field, c.1920. In 1912, the Old Boys founded a cricket club and played
matches against Essex and North London sides. A.H. Self was the first-team captain.

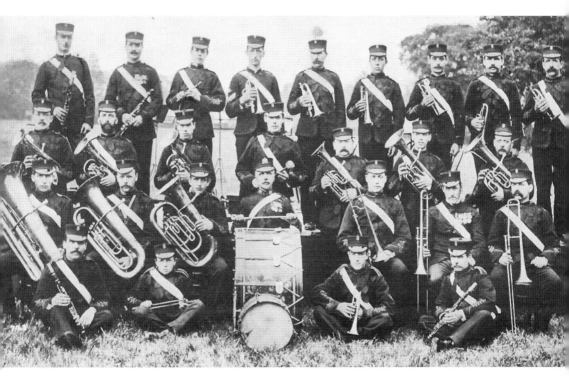

The Woodford Military Band, 1903. The band held practices every Tuesday and Thursday evening at the board school, Woodford Green, at 8.00pm. The Honorary Secretary was A. Liddle of Derby Road, Woodford.

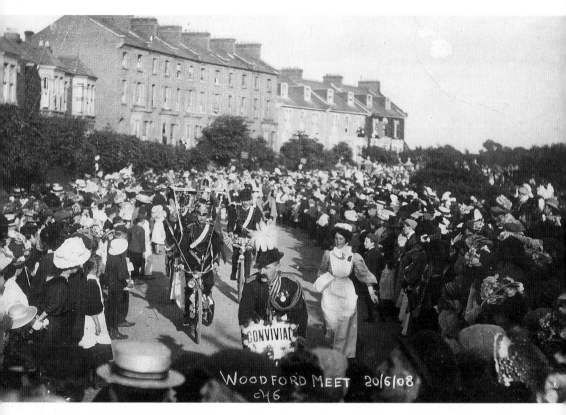

WOODFORD MEET 20/6/08
C46

The 'Woodford Cyclists Meet' passes the Green Man at Leytonstone, 20 June 1908. The Woodford Meet District Cyclists Association was founded *c.*1898 and organised the biennial procession until 1914. Cyclists in fancy dress and historic costumes would 'meet' by the castle on Woodford Green and cycle to Riggs Retreat. On the return night-time journey the cycles were decorated with coloured lights and the event attracted great crowds from all over suburban Essex.

three

Wanstead and Woodford

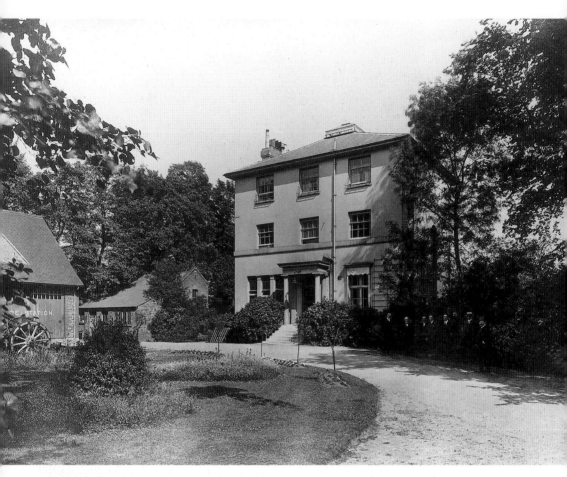

The Willows on Broadmead Road, *c*.1920. This early-nineteenth-century mansion was used by the Woodford Urban District Council as offices. The fire station was in its grounds and the fire house pictured on the left can be seen more clearly on pages 92 and 93.

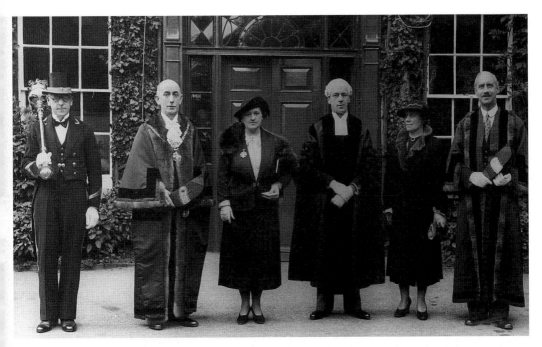

The Mayor, Sir James Hawkey, and his wife; the Deputy Mayor with his wife; and R Trend Binks, the Town Clerk, pose outside the council offices on the day when Wanstead and Woodford became one borough, 17 October 1937.

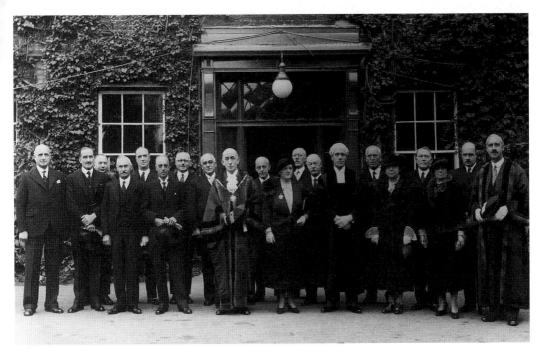

Sir James and Lady Hawkey surrounded by council members on Incorporation Day, outside the High Road council offices, Woodford.

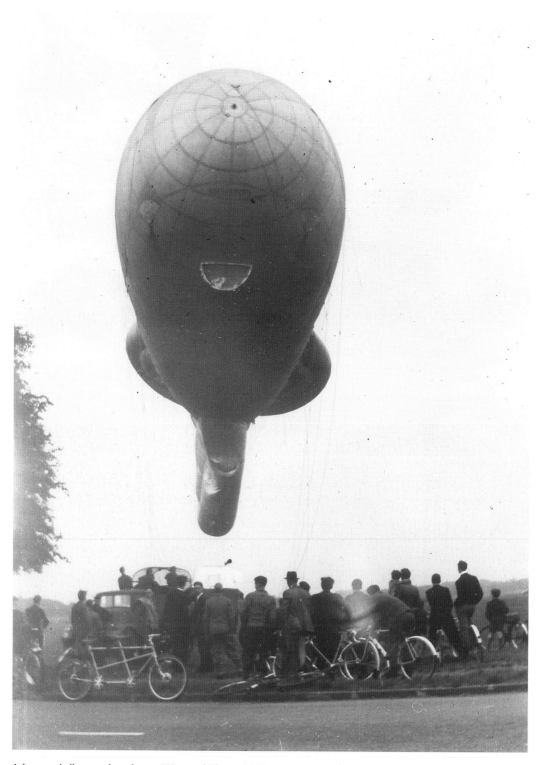

A barrage balloon tethered over Wanstead Flats, *c.*1942.

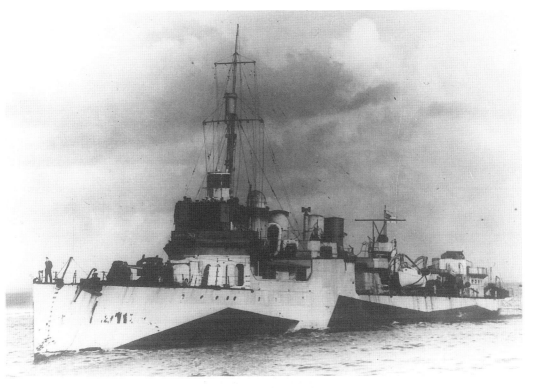

HMS *Churchill* enters Algiers Harbour on troop-convoy duty as part of Operation Torch in 1942.

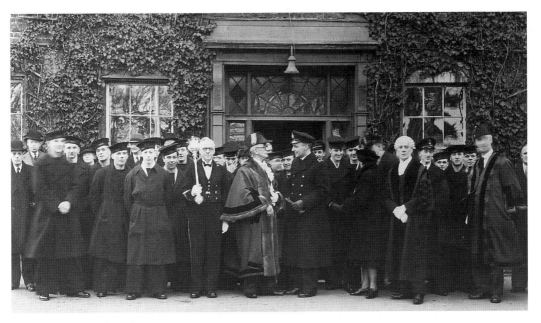

The captain and crew members of HMS *Churchill* with the Mayor and Council Members, 3 March 1944. The ship was 'adopted' by the Borough of Wanstead and Woodford during the Second World War as a means of increasing war savings.

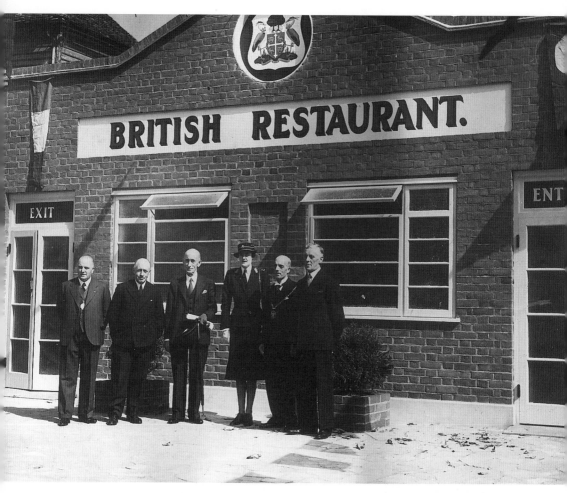

The Duchess of Marlborough and civic dignitaries at the opening of the British Restaurant in Wanstead High Street, September 1943. This building, one of a number of British Restaurants in the borough, was agreed at a council meeting in April 1943. It was built by Pace Brothers of South Woodford at a cost of £1,863 14s 6d. Supervisors at these council restaurants could expect wages of £4 5s a week while part-time kitchen hands would earn £1 2s 6d.

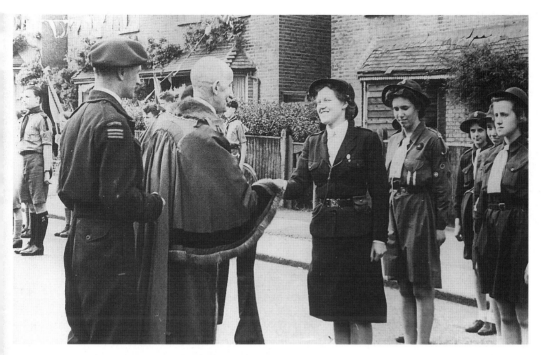

A Civic Sunday parade 'somewhere in the borough' in 1944. The Mayor, Sir James Hawkey, meets local Girl Guides outside bomb-damaged buildings.

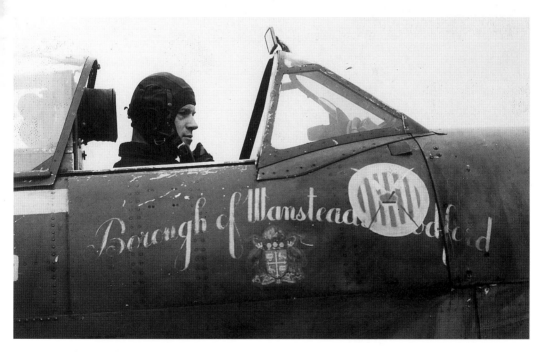

One of the spitfires 'bought' by local residents from War Savings. The first aircraft, VBP 8789 of number 118 Squadron, was lost on 1 June 1942. The name was transferred to AA 882 which survived the war and was scrapped in August 1945 to the value of £100.

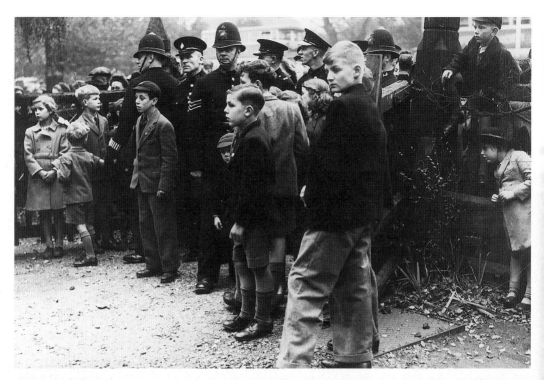

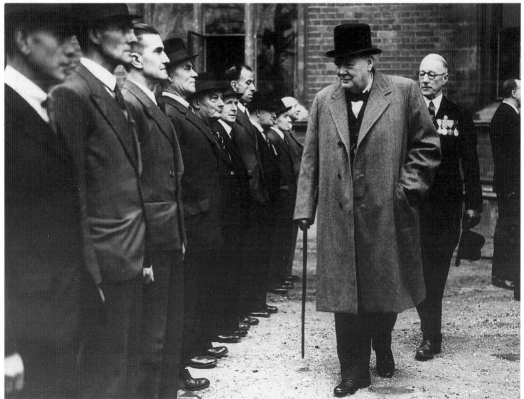

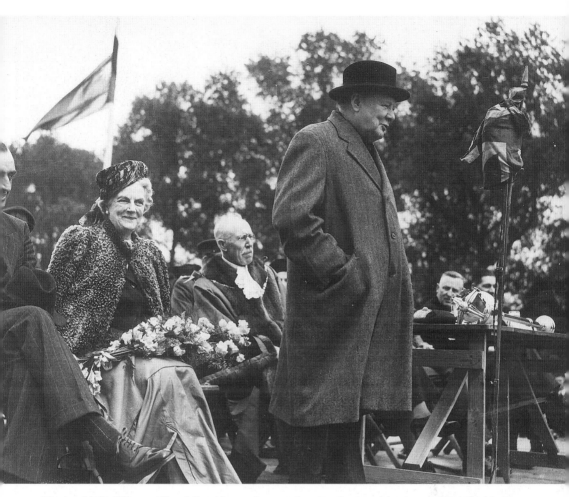

The local MP, Winston Churchill, addresses the crowd at the victory celebrations in Woodford in June 1946. On his right are Mrs Churchill and Roger Hawkey.

Opposite above: Crowds wait for Winston Churchill to arrive on 20 October 1945 to accept the Freedom of the Borough.

Opposite below: Churchill inspects British Legion members on the same day.

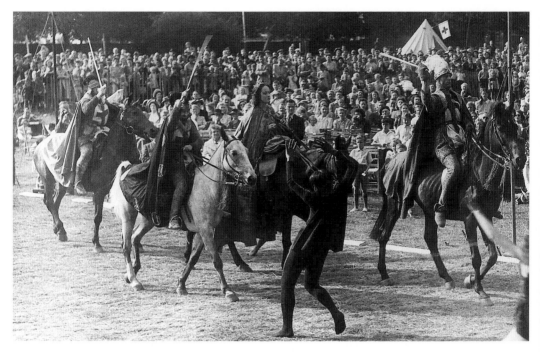

Part of a historic parade during the road safety pageant on Woodford Green in 1948.

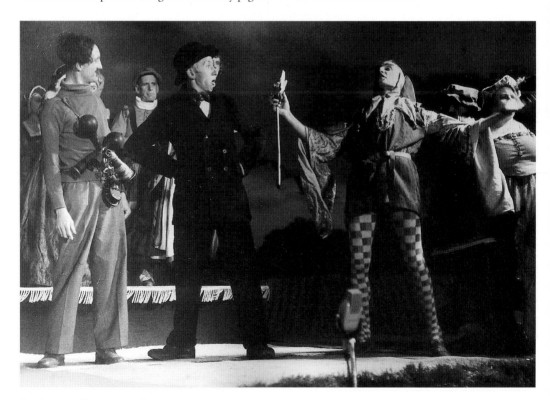

A cabaret performance at the pageant.

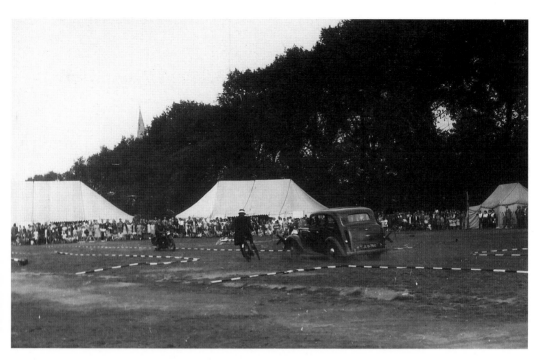

A demonstration of driving skills at the road safety pageant.

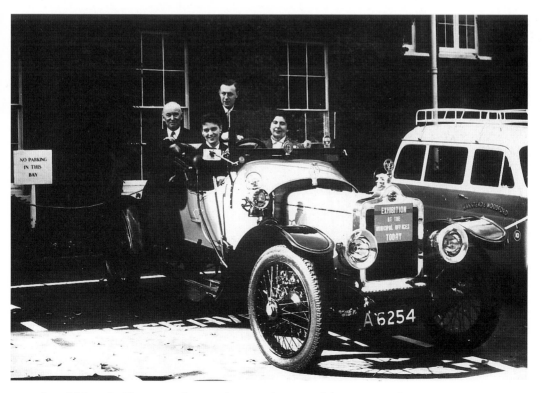

An exhibit at the *Transport in the Borough, Past and Present* exhibition in October 1957.

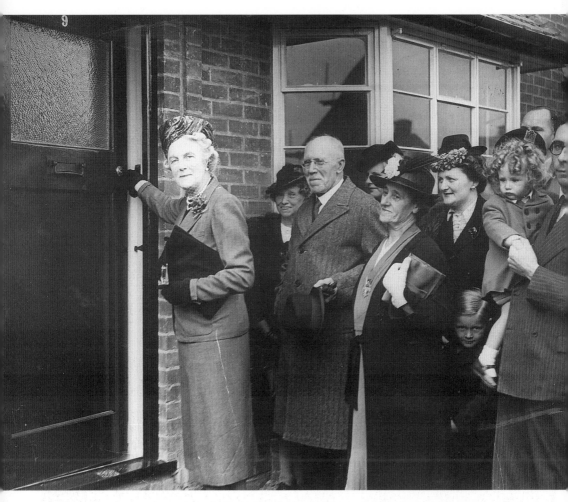

Mrs Clementine Churchill opens the door of the 1,000th new home built in the borough since 1945 on 14 July 1951.

Opposite above: Sir Winston Churchill arrives for the opening ceremony of the Sir James Hawkey Hall on 26 March 1955.

Opposite below: A plaque commemorating the contribution of the former mayor is unveiled by the Prime Minister.

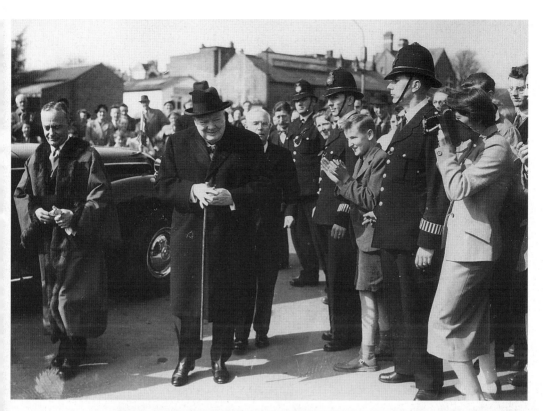

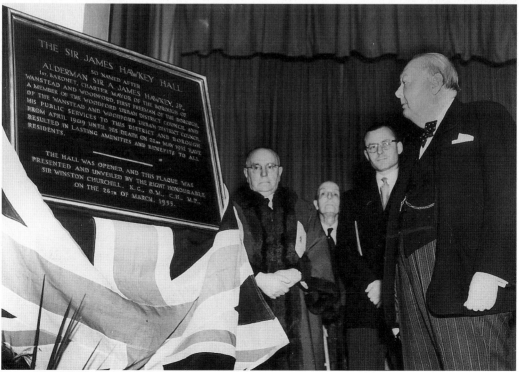

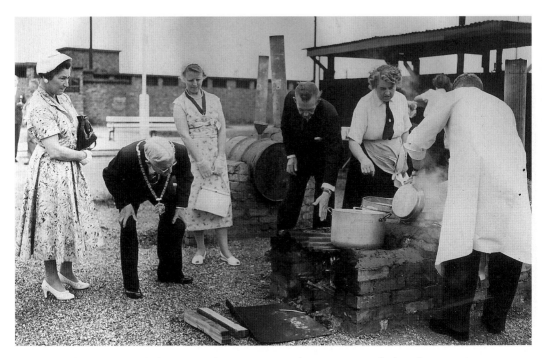

Dr Sylvia Ashton, Mayor Charles Moss and Doris Moss watch an emergency feeding demonstration involving a trench cooker which was organised by Woodford Civil Defence Corps on 19 June 1957.

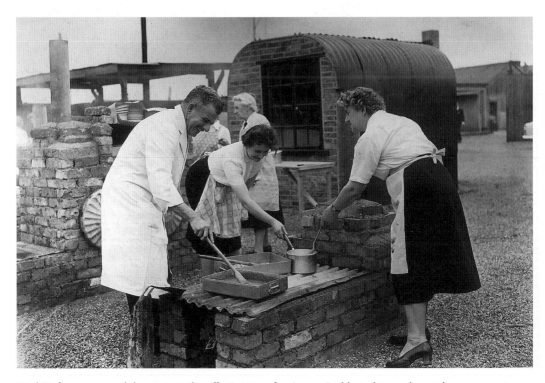

Civil Defence personnel demonstrate the effectiveness of an improvised hot-plate cooker at the same event.

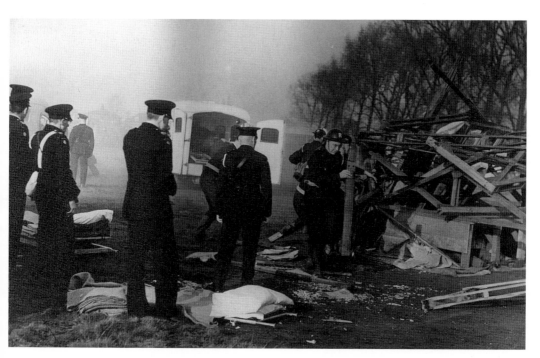

A Civil Defence exercise at Woodford Green on 3 March 1951.

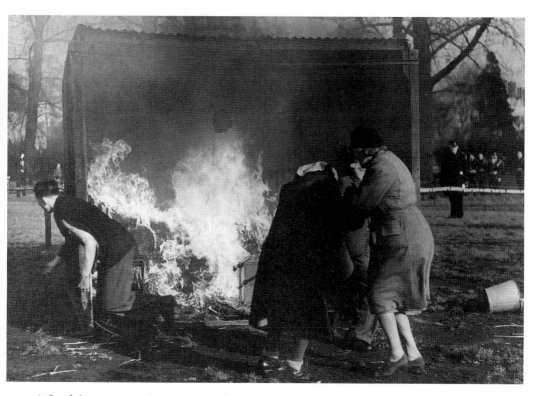

A fire-fighting exercise during Civil Defence Week in 1951.

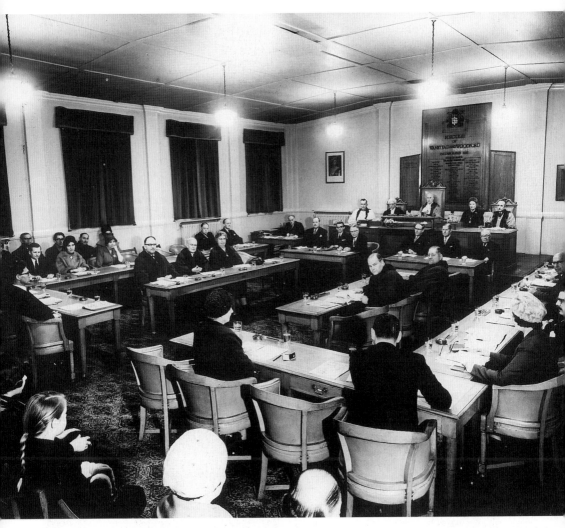

A meeting of Wanstead and Woodford Council officers, 5 January 1963. The Mayor is Councillor
W.O.J. Robinson with E.V. Gardner his deputy. The offices were sited in the former St Mary's
Rectory in the High Road, Woodford.

Opposite above: Alderman R.W. Dale, the Mayor and council officials at a civic function in 1950.

Opposite below: The Silver Jubilee ball of the borough on 18 October 1962. The guests include from left
to right, Dr Sylvia Ashton, Councillor Roy Dalton, John Harvey MP, Mayor W. Robinson, Councillor
Bob Mitchell, Alderman Charles Moss, Mrs Doris Moss and Mrs Ronnie Mitchell.

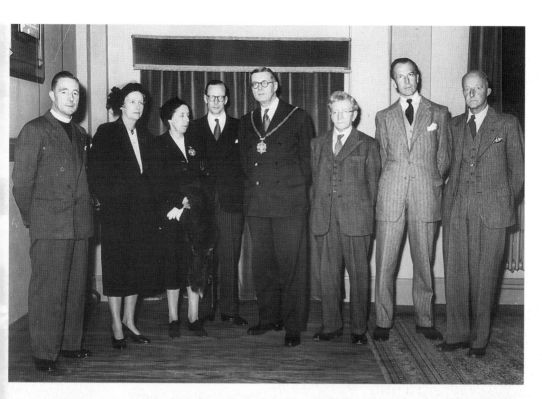

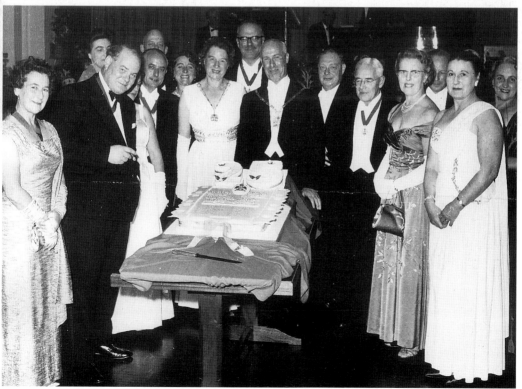

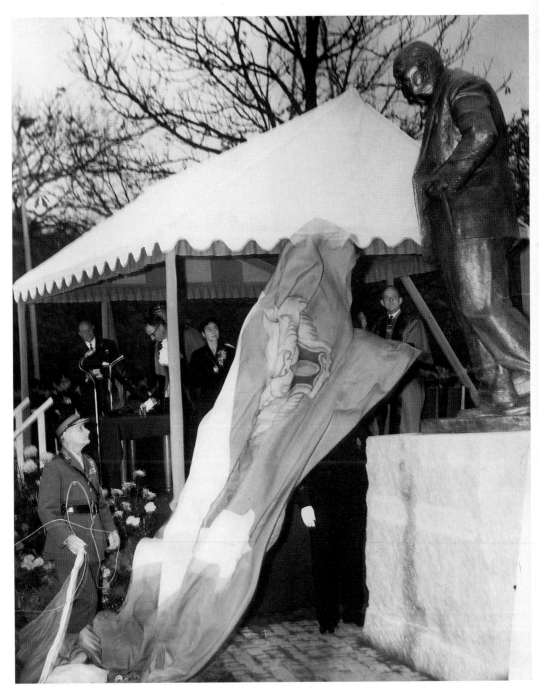

The unveiling of the statue of Sir Winston Churchill on Woodford Green by Field-Marshall Viscount Montgomery on 31 October 1959. The eight-foot-high statue, sculpted by David McFall, cost £5,000 and was paid for by donations from all parts of the world.